My Chinese Sketchbook

TRANSLATED FROM THE FRENCH BY
Susan Schneider

COPYEDITING
Fui Lee Luk

TYPESETTING
Claude-Olivier Four

PROOFREADING
Mark Simpson

COLOR SEPARATION
Eurésys, France

Distributed in North America by Rizzoli International Publications, Inc.

Previously published in French as *Mes Carnets de Chine*
© Éditions Flammarion, 2002
English-language edition
© Éditions Flammarion, 2005

26, rue Racine
75006 Paris

www.editions.flammarion.com

05 06 07 4 3 2 1

FC0480-05-II
ISBN: 2-0803-0480-1
Dépôt légal: 02/2005

Printed in Spain by JCG

My Chinese Sketchbook

FU JI TSANG

Flammarion

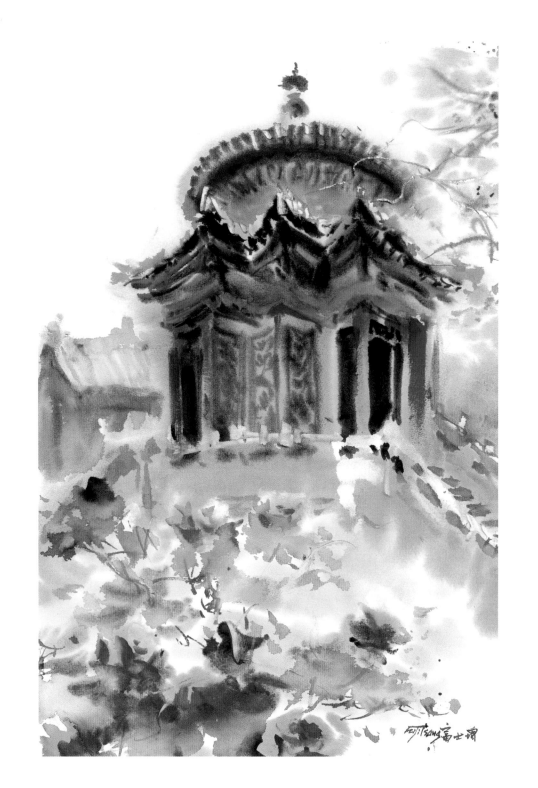

I dedicate this book to Thomas, Clément, and Vincent,
my three children from a Franco-Chinese union.
Theirs will be the task of rising to tomorrow's challenges
and of acting as a link between peoples and continents.

FU JI TSANG

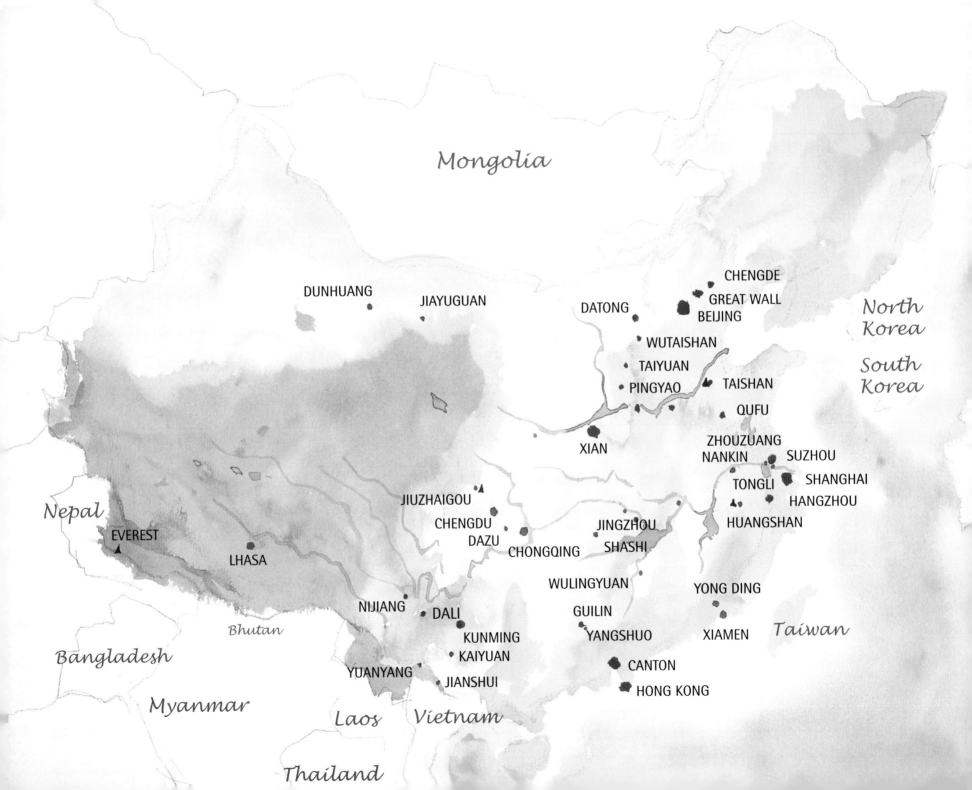

CONTENTS

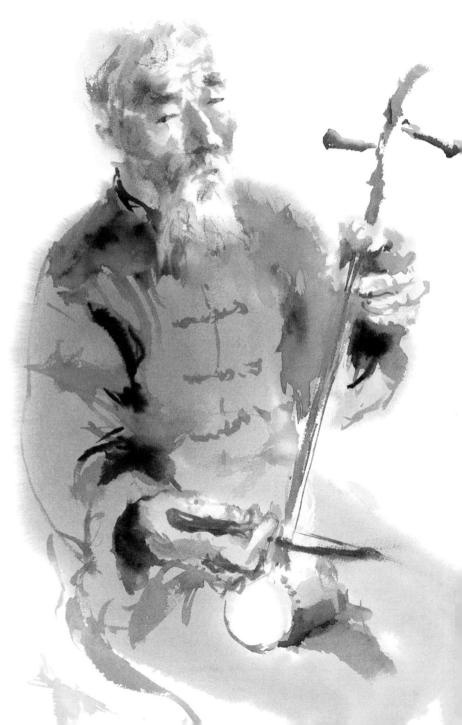

FOREWORD — 9

BEIJING — 15

HUANGSHAN — 33

ZHOUZHUANG — 41

THE SUZHOU AND HANGZHOU REGION — 45

STONES — 57

LIJIANG, DALI, AND KUNMING — 65

CALLIGRAPHY — 73

CHINESE MUSIC — 77

TRADITIONAL CHINESE DANCE — 85

TAISHAN — 89

XIAN — 95

FROM XIAN TO DATONG — 103

THE DATONG REGION — 107

CANTON AND HONG KONG — 113

GUILIN AND YANGSHUO — 121

CHINA, LAND OF SIXTY ETHNIC MINORITIES — 125

SHANGHAI — 129

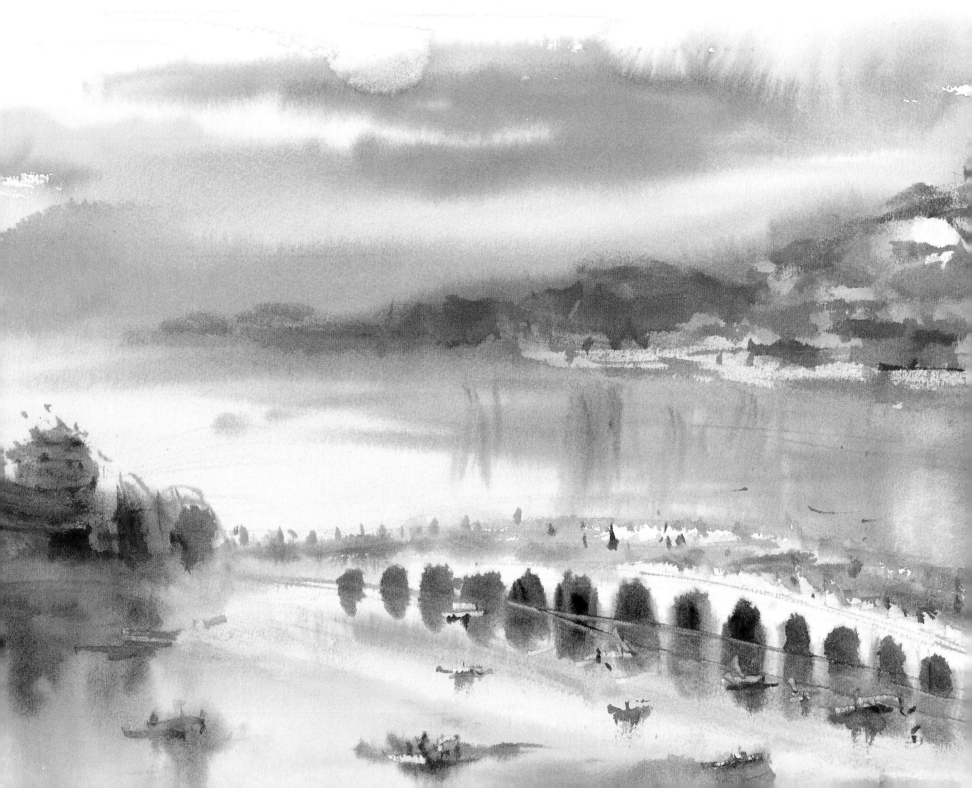

MY CHINESE SKETCHBOOK
Preface

孔子格言
智者樂水
仁者樂山

CONFUCIAN MAXIM
"The sage delighteth in water,
the humane man has amity with the hills."
From The Analects VI.21 (in Cheadle, Mary Paterson.
Ezra Pound's Confucian Translations. Ann Arbor:
University of Michigan Press, 1997, p. 230)

I was born in Beijing in 1958. My father, a dental surgeon, was of Manchu-Mandarin stock. My mother was born in Indonesia to an overseas Chinese family. I started my elementary school education at the outset of the Cultural Revolution. As this country held no future for us, my family made the painful decision to leave for good.

At eighteen, I arrived in Hong Kong—a place seething with myriad activity—where I lost all my Chinese bearings. Here, one no longer worked for the edification of the Communist Party and the only watchword was "Get rich quick." My passion for art helped me to find my way through this modern-age jungle. Free at last! And free to dream ... to dream of seeing original masterpieces in museums, rather than stealing furtive glimpses at poor-quality reproductions in magazines. To dream of living as a free artist, or of studying art in France. Yet I had to work hard to turn these dreams into reality. I did all kinds of "odd jobs" to finance

9

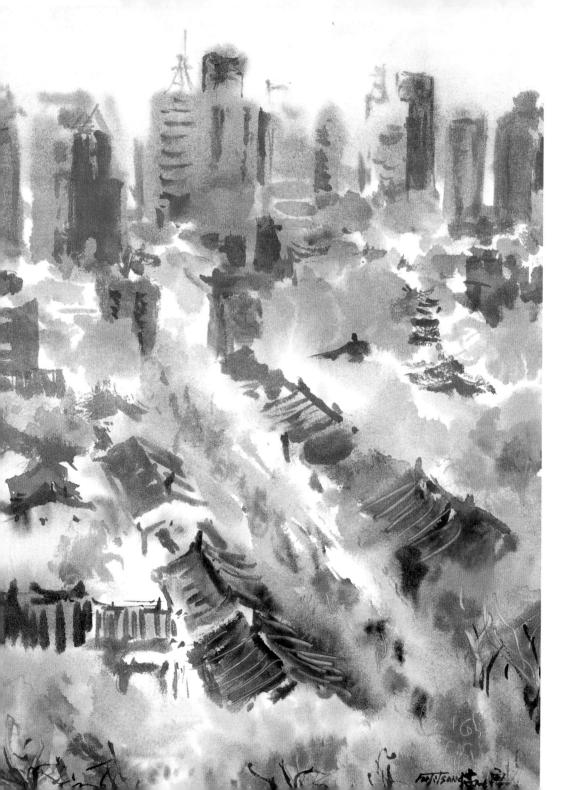

Skyscrapers surrounding old Beijing
In Beijing, as in all Chinese cities,
the demolition of old districts
to make way for skyscrapers
and wide boulevards
is the current leitmotiv.

my lessons at the Alliance Française (French Institute) in Hong Kong. It was there that I got my advanced certificate, mandatory for anyone wanting to study at university in France.

In 1979, my efforts paid off: I went to France and gained a place at the École Nationale d'Art Décoratif in Nice. In 1985, I obtained my art diploma. The same year I was chosen to accompany a group of young French students who were to take the Trans-Siberian railway from Moscow to Beijing. For me, this was an incredible opportunity to set foot again in my homeland for the first time in nine years! However, the Iron Curtain was firmly in place and, as a Chinese turncoat, I was not allowed to cross the Eastern Block by train. Undeterred, the French organizer sent me directly to Beijing by airplane.

China was beginning to open up to the outside world after thirty-six years of isolation. Hope was in the air, despite

MING TOMB
Each of the thirteen tombs
comprises ritual ceremonial palaces
in front of the burial mound and
is circumscribed by a high wall,
marking off the area to which
all access was formerly prohibited.
Hundred-year-old pines and cypresses
lend a grave air of solemnity to the site.

the mistrust of the Chinese authorities and the general fear felt by the local population. I was overjoyed to see old friends and schoolmates again, and I marveled at the sight of a culture and heritage so rich, yet neglected for so long. The years of revolution and political movements had taken their toll on China, leaving it a virtual ruin: a complete overhaul was in order. I felt the need to live through this time of transition and to bear witness to it in my own way.

Borne along by my brush and memory, I hope to share with you the originality of the music and the beauty of the landscapes; I want you to sway to the dance beats, to draw inspiration from the calligraphy, to imagine the majesty of the ancient sites, and to see the multicolored diversity of ethnic minorities, both past and present.

In China we say that a picture is worth ten thousand words. May the images in this book transport you in your dreams!

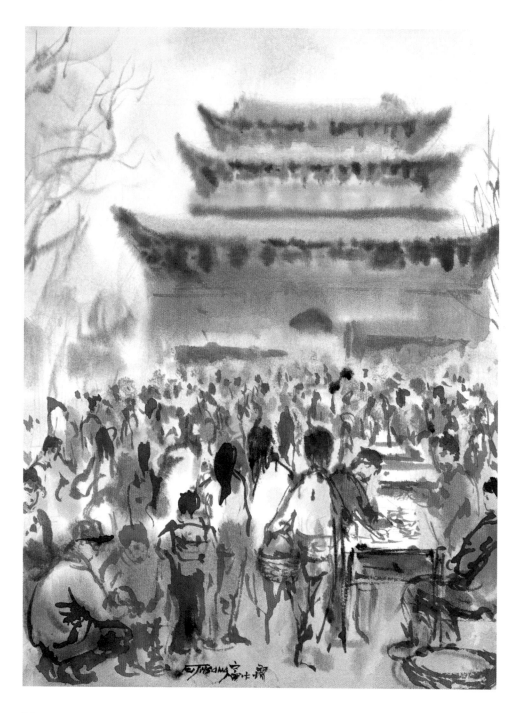

MARKET IN FRONT OF THE DRUM TOWER IN WINTER

Braving the Beijing
winter in the streets
every day
is no mean task.
The temperature
is always around
minus ten degrees
and the sand-laden
wind from Mongolia
angrily scours any
exposed areas of skin.
Fortunately, the
sun continues to shine.

BIRD LOVERS BEFORE THE BELL TOWER

Every ancient city has
a bell and drum tower
for telling the time.
The Beijing tower
is particularly awesome.
The Chinese are very
fond of birds, especially
those that sing or
imitate the human voice.
Discerning lovers of
these feathered friends
exchange "tips"
on how to get hold
of "champion" chirpers.

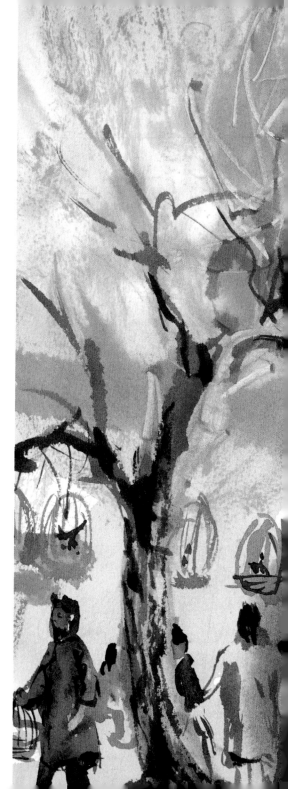

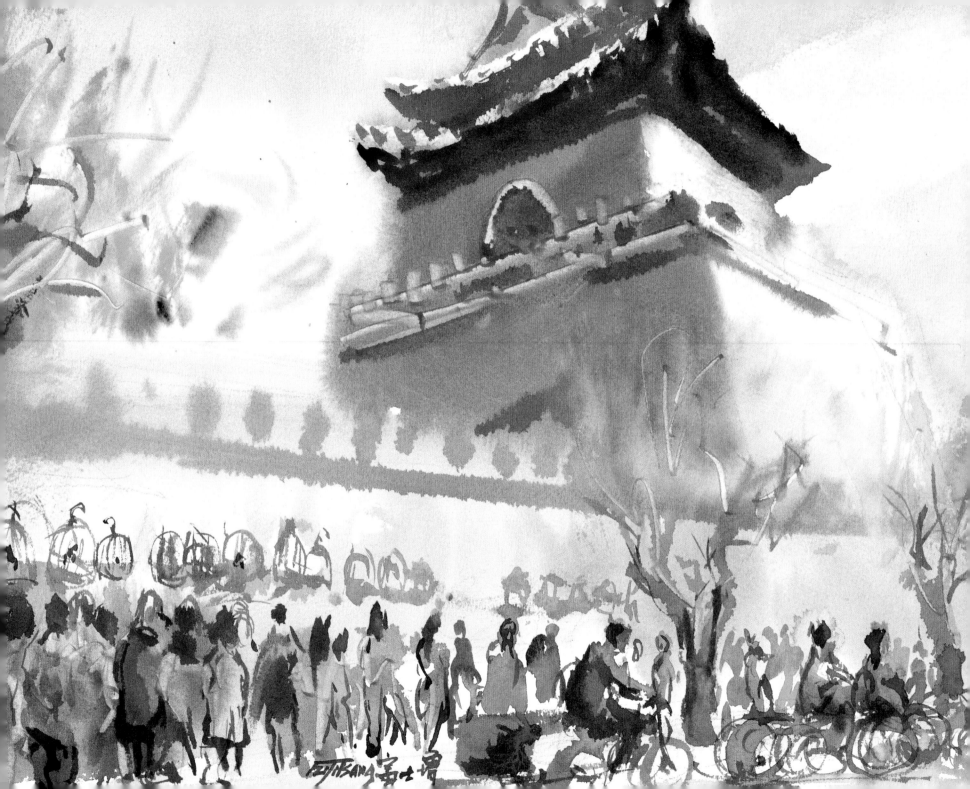

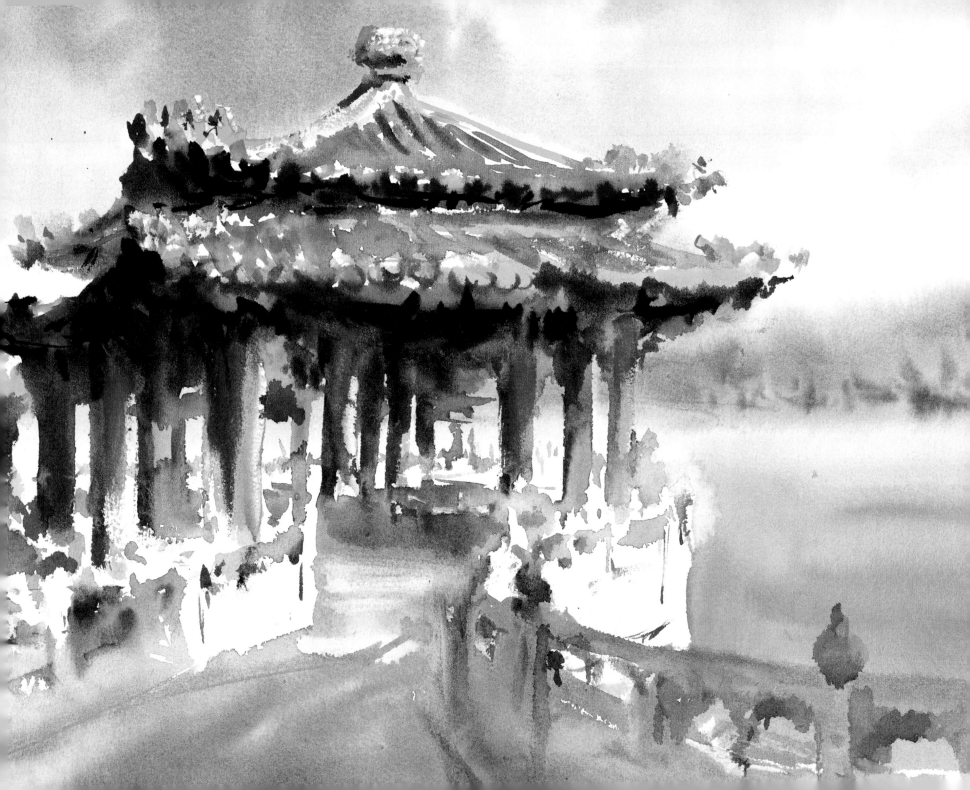

BEIJING
City of my birth and childhood

BEIHAI PARK (FACING PAGE)

YARD OF THE HOUSE WHERE
I WAS BORN (RIGHT)

All living beings have a singular attachment towards the place where they were born and grew up. Beijing is in a class of its own and is like no other city in China. It is an imperial city, the capital of three dynasties and of the present republic. It is here that are found the most grandiose palaces and the most sumptuous dwellings. The Forbidden City crosses the capital from north to south. Ramparts rising to well over a hundred feet (thirty meters) encircle the city, in which each trade and social class has its own district. Deep canals protect and embellish the imperial parks and palace.

I am once more back in the verdant parks of my childhood. I remember my "Impressionist" experience on the shores of Beihai Lake (known as the "North Sea") right next to the Forbidden City. Styling myself on Monet, who created the famous *Impression, soleil levant* (Impression, Sunrise), I decided to paint *in situ* surrounded by nature. Rising before dawn, I mounted my bicycle and pedaled as quickly as I could to the park. Once at the lakeside, I lost no time in unpacking my painter's materials and awaited the sun. It finally peeped its way out of the shadowy light. Feverishly,

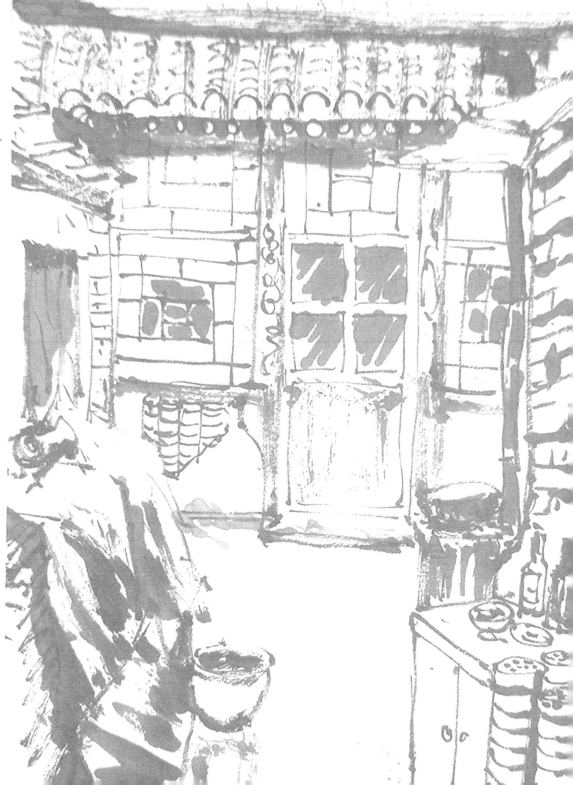

Kite-flying is one of the
favorite pastimes of the Chinese.

SOUTH GATE OF THE FORBIDDEN CITY
(FACING PAGE)

I tried to capture the hues of dawn. Yet before I had even managed to set down the first splash of color on my canvas, the sun was already high in the sky. Nothing was the same, the moment lost forever. That day I came to understand the meaning of Impressionism. The emotion I experienced then has remained with me ever since.

An artist conveys emotion in his own way. Yet where does this come from? It is of little concern. All that matters is the creator's sincerity, for this is what evokes a similar sensation in the viewer.

I learned how to write calligraphy at school. At home, an art teacher gave me lessons in Western-style perspective and drawing. This opened up exciting artistic vistas for me very early on. I was equally fascinated by the brushstroke's spontaneous inky swirl and the scientific rigor of the European analysis of colors and values.

I love Beijing for its Forbidden City. All is solemn and grandiose: rampart after rampart over thirty feet (10 m) high and almost fifty feet (15 m) wide, and an impressive number of rooms. The Hall of Supreme Harmony is the most imposing structure of ancient China, with its monumental staircase adorned with nine dragons carved from a block of marble and measuring over fifty-two feet (16 m) long and weighing some two hundred tons. Yet it took less than fourteen years to create this extraordinary site. Over a million workers from all over China were involved in its construction.

When I was a child, I visited this palace on many occasions with my grandparents. My grandfather liked to explain how the place had witnessed important events such as the fall of the Ming dynasty when the Manchurian army entered the City, the Boxer Rebellion, and the creation of the first republic.

I was particularly drawn to the clock museum. One of the oldest clocks there—a piece standing over thirteen feet (4 m) high—tells the time using water that flows between reservoirs placed at various levels. Another series of clocks works with a cog mechanism equipped with a system of springs that sets some figurines in motion. They were a gift from European ambassadors over a century ago. I would

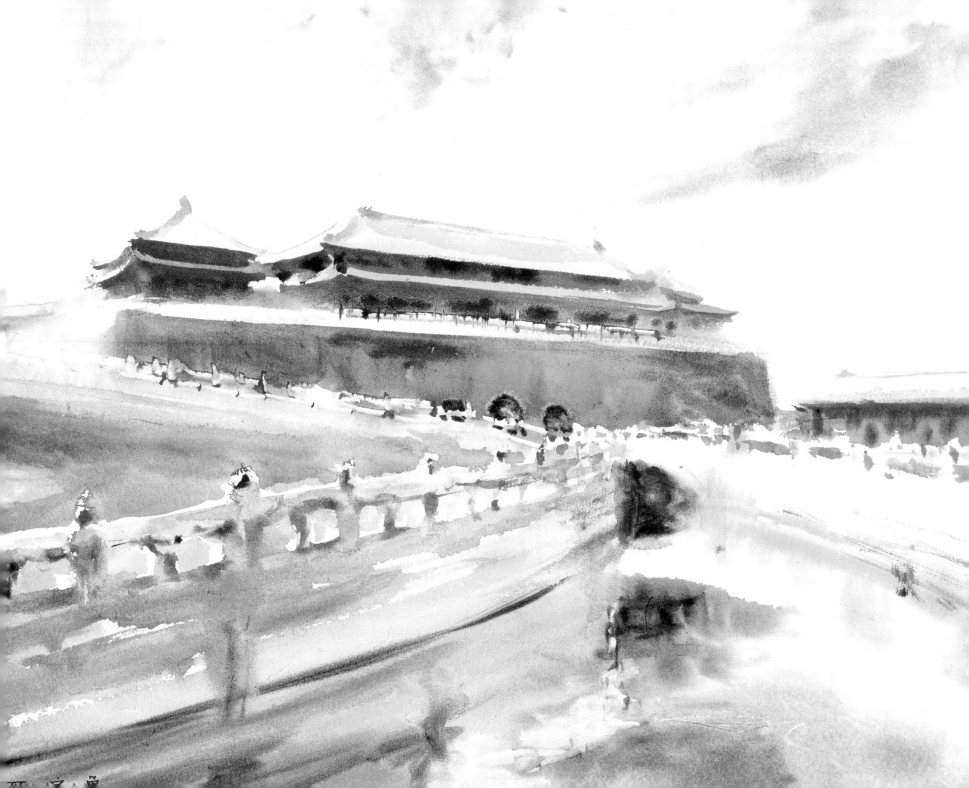

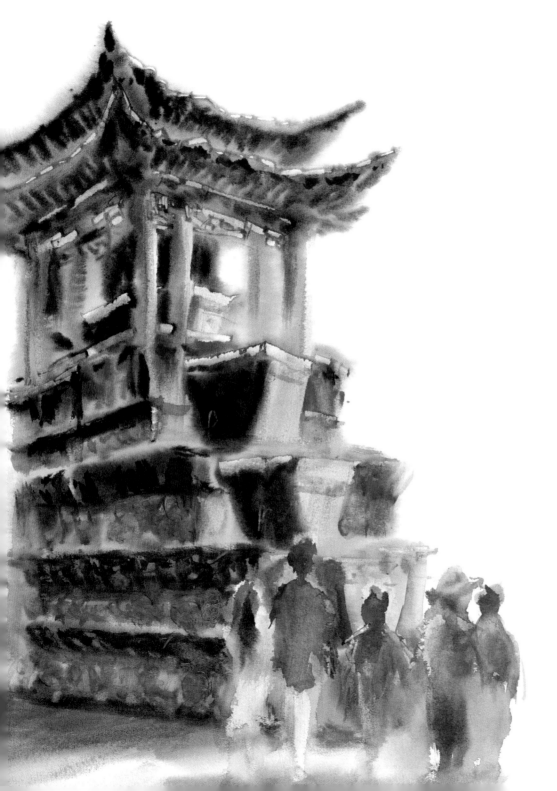

BEIJING'S "BEEF ALLEY" (FACING PAGE)
This Muslim district is known for its
restaurants that serve beef-based specialties
and for its traditional architecture.

spend hours looking at them. These Western "long noses"
were true geniuses when it came to inventing objects that
were so much more exciting than any of my toys! By "toys,"
I mean little ice-cream sticks made of bamboo or cigarette
packet wrappers. Yet, along with the other children in the
neighborhood, I would happily play with these items in the
street, investing them with extraordinary meaning and value.

When I was a teenager, there was no private trade.
The State stores offered a hopelessly limited choice of items
and the sales clerks were far from welcoming. Restaurants
were expensive and demanded ration vouchers. Today, there
is a whole host of small traders. Restaurants offer live
seafood, fish or more exotic delights, such as certain ven-
omous snakes. One of my old high-school classmates runs
a local restaurant that serves authentic Beijing dishes. The
premises stand in stark contrast to the refinement of the
cuisine: a faucet above what is just a hole serves as a wash-
basin and the toilets—very basic in style and rarely cleaned—
are located a few blocks down the road. The little street
eateries are even more rudimentary, boasting only a simple

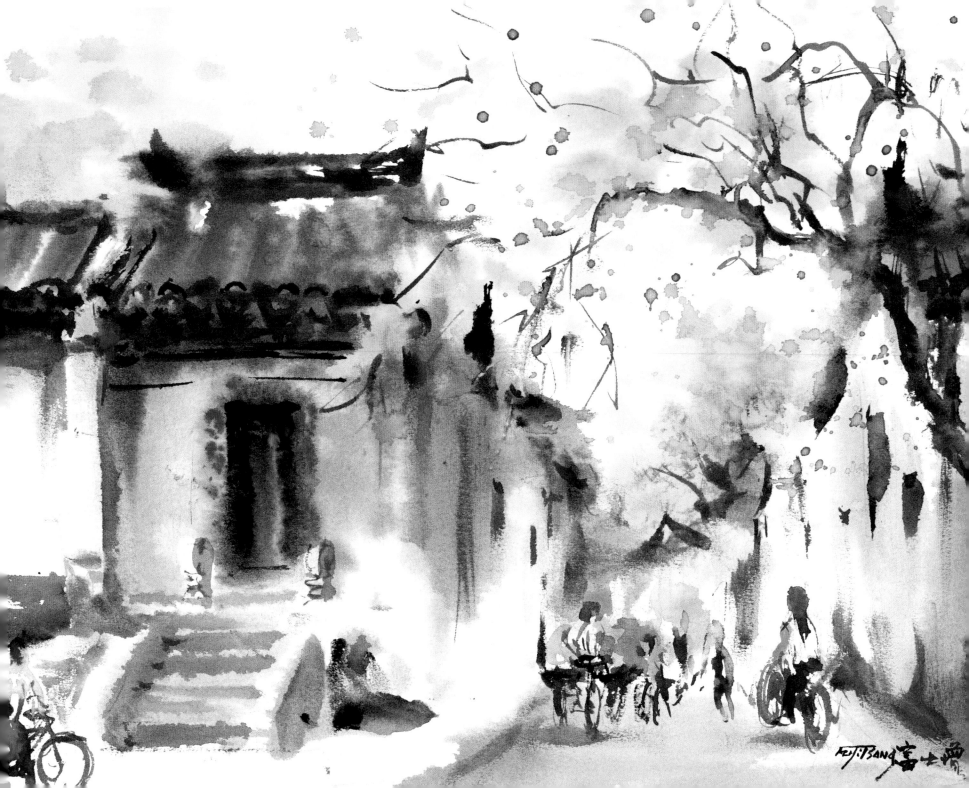

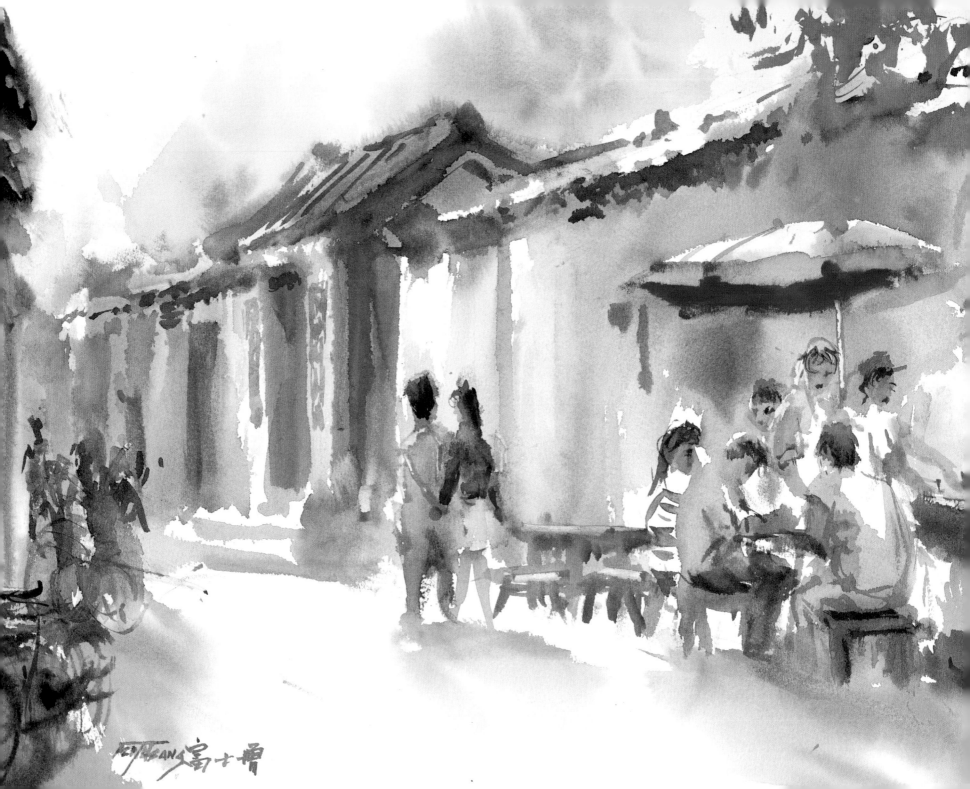

coal-burning stove and wok, the ubiquitous large frying pan with a rounded base used in Chinese cooking. There is just one basin where the kitchen hand does the dishes. The cook chops the meat and vegetables on a board placed directly on the ground. Yet the food is unique and its flavor unparalleled. There is one cook who, in a matter of minutes, will whip you up—as only he knows how—a heavenly broth using noodles or dumplings sprinkled with a pinch of fresh coriander. Another small street-corner trader fries cubes of fermented soy tofu that gives off a stench as unpleasant as its taste is delicious. If my French friends turn their noses up at this, I like to point out impishly that some French cheeses are indeed not without their whiff factor!

Markets form an integral part of Beijing life. Two of the most famous of these are the antique market and the Donganmen district night market. At the former, situated in the district of Liulichang, one can find both genuine and fake antiques. But its handicrafts are the real draw. I met one man there, aged around sixty, who makes miniature, multicolored kites that actually fly. Another, armed with only a pair of scissors, makes paper cuttings that are so

detailed they have to be admired for their precision. Yet another uses reeds to create three-dimensional animals that delight collectors the world over.

At nightfall, when the stores close, the night market with its festive atmosphere takes over Donganmen Street. "Hip" young people and country folk flock there to buy counterfeit goods or simply to stroll. On a rickety shelf lit by a yellowish light are albums by American singers—a snip at ten *yuan*—next to French-brand belts reduced to twenty *yuan*. However, to make the most of these "once in a lifetime bargains," it pays to know a few simple rules of bartering! The stallholder sizes up the customer, then gives his price. You should have no qualms in retorting with a figure much lower than what you believe to be a fair price. The seller will never lose his cool, but will lose interest in you if your price allows him no leeway for a small profit.

The Great Wall, the symbol of China, stretches from Shanhaiguan on the east coast to Jiayuguan in the Gobi Desert. The portion of the Great Wall at Badaling—the "peak of eight directions"—was opened to the public in 1957.

23

北
京
BEIJING
City of my birth and childhood

It was here that I went as a child. As the train journey there would take hours, we would take with us a picnic and a water bottle. A magnificent sight awaited us: beautiful natural surroundings and the gigantic Wall. Today much has changed, with the influx of throngs of tourists, stores selling trinkets and fast-food restaurants. This portion of wall is the closest to Beijing and also the most highly esteemed. When Mao Tse-tung visited the site, he declared that a man is not fit to be called a man if he has not set foot on the Great Wall. Ever since, Chinese people of all ages have flocked from the four corners of the country to take this symbol by storm, and leave with a certificate to prove it!

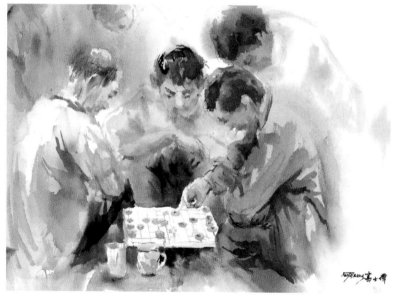

Another portion of the Great Wall has been restored and opened to the public at Mutianyu. Here, the valley narrows to form a funnel shape. A stronghold was erected at

this strategic site complete with imposing ramparts and barracks, branching off into two wings to the east and west. I take the longer of the two to the west. The slope is very steep and, after crossing several watchtowers, I arrive at a deceivingly flat incline. Few people get this far, exhausted by the relentless effort of ascent. I continue to work my way up and reach the last tower. Beyond this, I can make out the ruins of the old wall overtaken by nature and trailing off behind a ridge. I head back eastwards: like a silken ribbon, the other wing snakes its way up the mountain in the rays of the setting sun.

The third portion, at Simatai, receives far fewer visitors. You need to be in good shape to cover its twelve-mile (19km) span and 135 towers! With its sheer, almost vertical, slopes—sometimes in a sorry state of disrepair—it is the

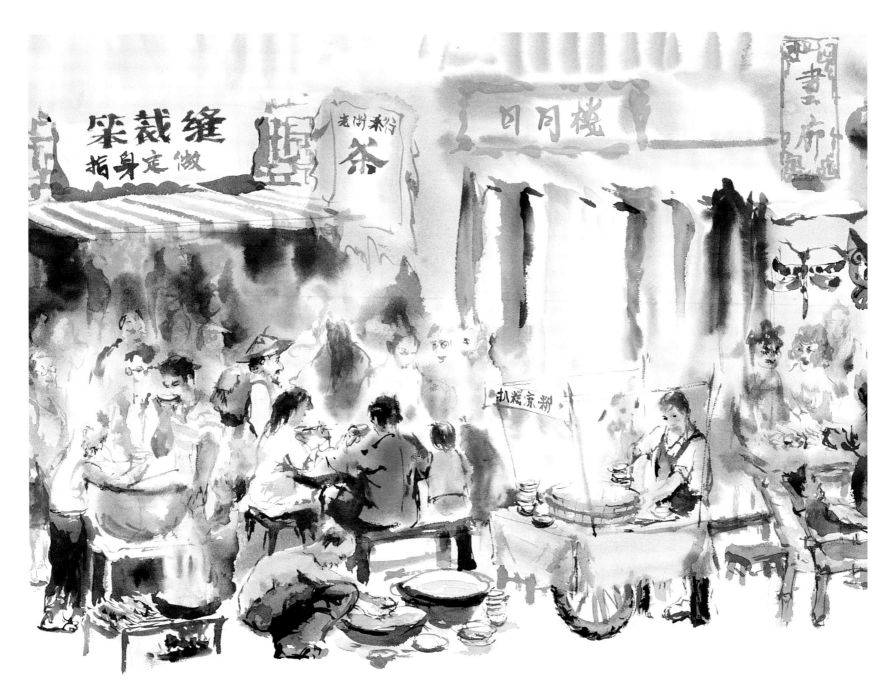

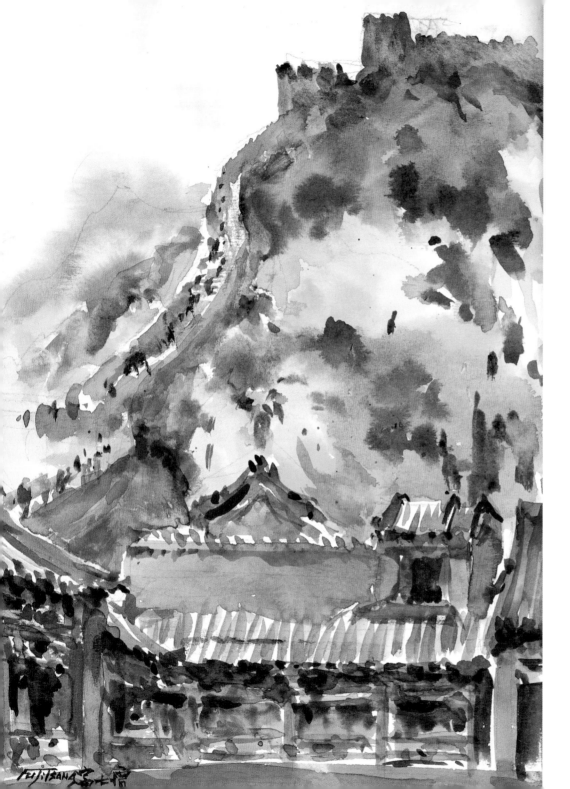

GREAT WALL AT MUTIANYU
Seen from below, the Wall
rises almost vertically.
Thousands of uneven steps await you.
The way up is hard on the lungs and
thigh muscles; going down,
it is the calves' turn to suffer.

most spectacular and the most demanding of all of the portions of wall I have visited.

My favorite section of the Great Wall is at Jinshanling, known as the "Gold Mountain." I went there on my way back from Chengde, the summer resort of the Qing Imperial Court. The high, wide walls and irregular, uneven steps soon got the better of me. From one watchtower atop a cliff I could see the section of Wall known as the "Gaping Jaw." Straddling mountain ranges that go on for hundreds of miles, it is quite simply grandiose!

Chengde was originally a Tartar city. It was here that the Manchus, accustomed to the coolness of the steppe, set up their summer dwellings. These now-sedentary nomads were able to preserve their traditions through hunting and horseback sports. The imperial Summer Palace reached its heyday during the reign of Qianlong around 1790 when it covered an area of five hundred and sixty hectares. The earliest buildings were styled on the Forbidden City with respect to the pomp of the Court. The columns and

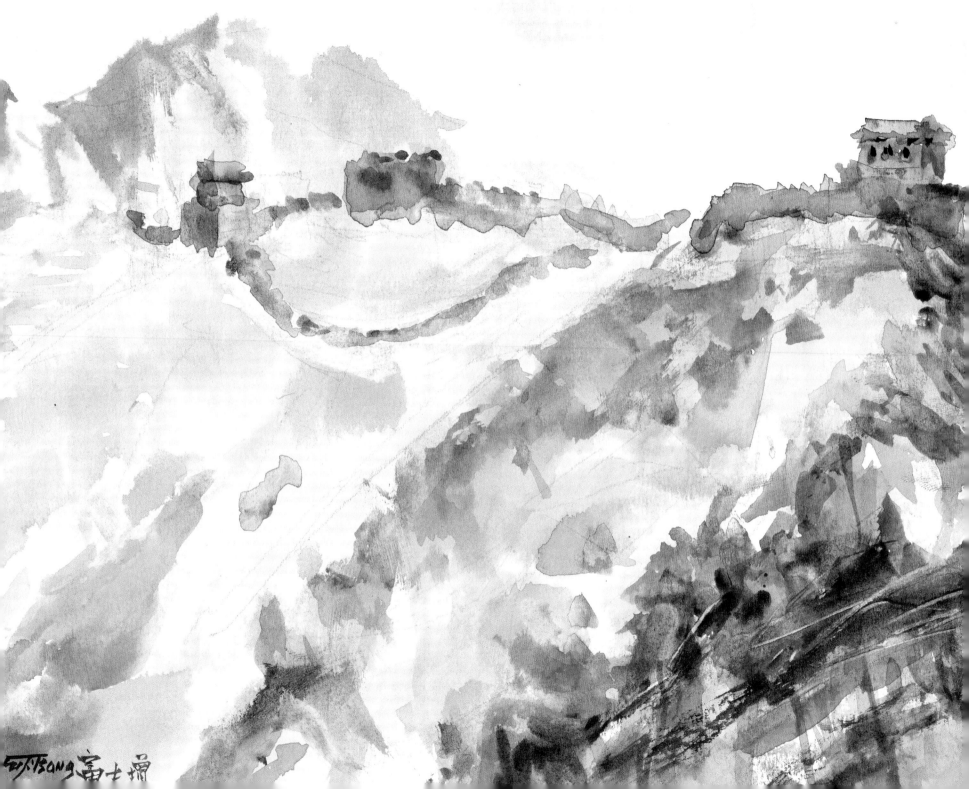

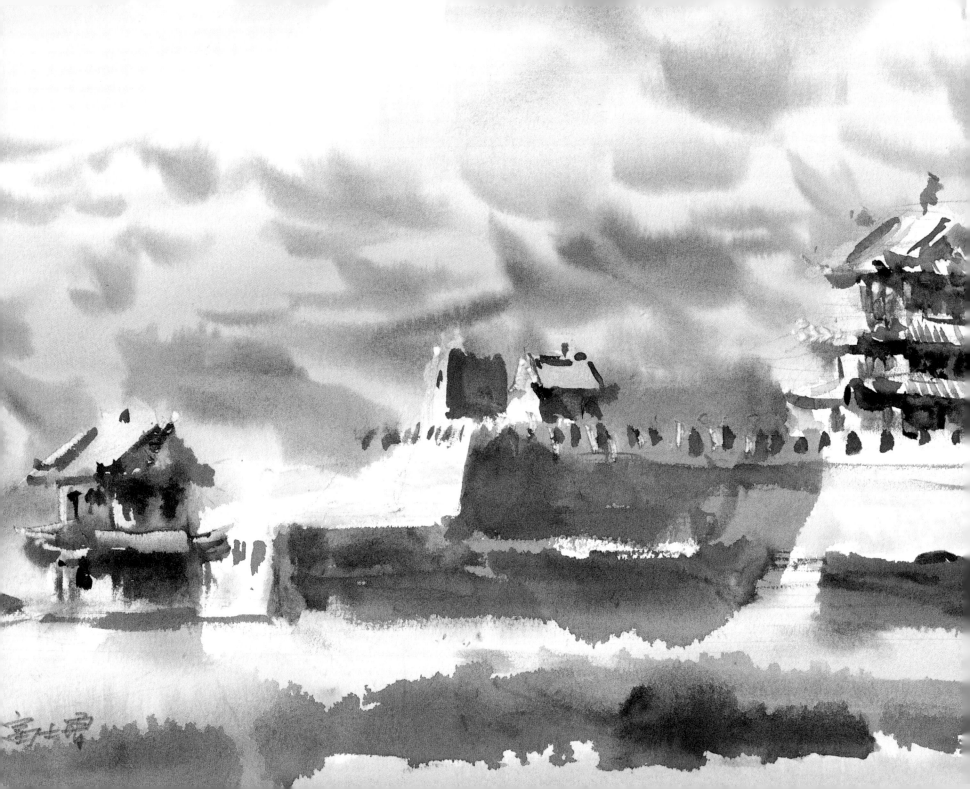

windows, taking their cue from the more sober style of
southern architecture, are made of untreated wood and lack
the red varnish that was usually applied to official edifices.
Such sobriety detracts in no way from the solemnity of the
site. To the rear of the palace, set around a lake with its
sprinkling of small islands, are pavilions reminiscent of the
architecture of the Chinese minorities. Unfortunately, a cen-
tury of war and revolution has lain waste to many of these
seventy-two sites.

A building has been erected at each of the four car-
dinal points of the city, with the palace in the center. To
the north, on the far bank of the Shizi River, the Putuo-
zongsheng Temple is a smaller-scale model of the Potala
Palace in Lhasa. The solemn earthenware stupas at the
entrance serve to remind visitors that they are setting foot
in a sacred place. Large trees buttressed by beams line the
path leading to the main building. A huge wall dotted with
windows blocks the way. It occurs to me that the openings
are not rectangular in shape, but narrower at the top than
the bottom, thus accentuating the overall effect of height.

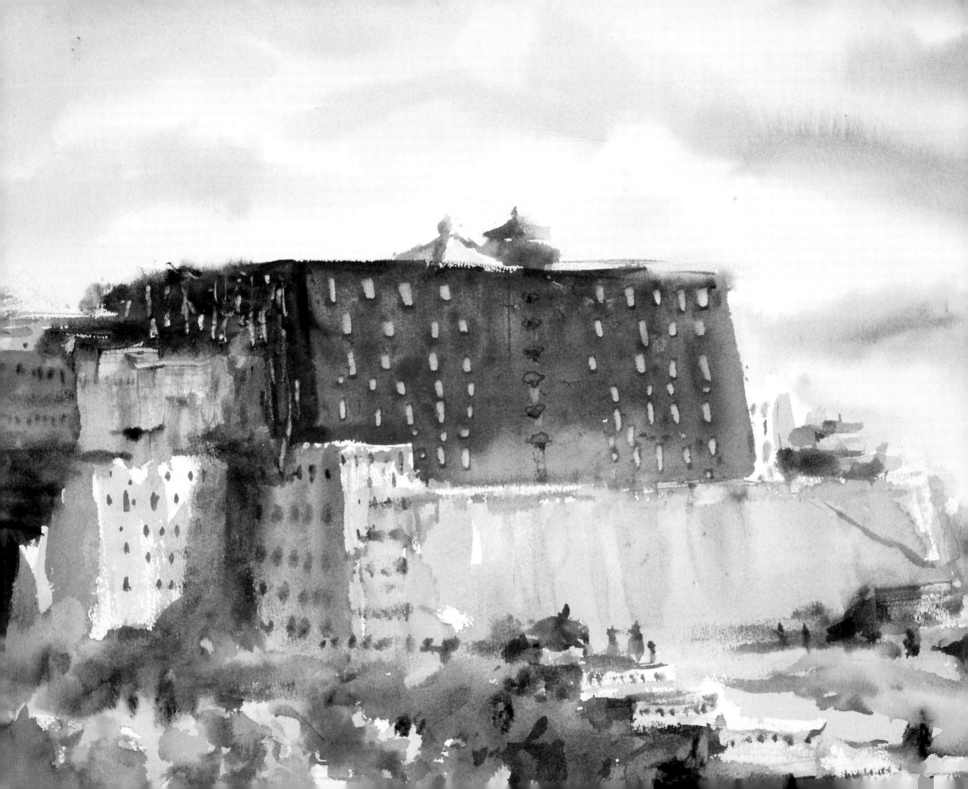

北京 BEIJING
City of my birth and childhood

THE SMALL POTALA (FACING PAGE)

TANTRA (RIGHT)

A staircase that starts off wide on the ground floor until the first landing, becomes progressively steeper and opens onto a courtyard in the middle of which towers a square temple housing a great statue of Buddha. A three-story building surrounds it with covered galleries. On the round terrace that forms the roof of the top floor, multicolored banners flap in the north wind against a sky of blue. Made of gold-plated copper, the tiles of the central temple sparkle brilliantly. The sobriety and solemnity of the exterior stand in stark contrast with the opulence and refinement of the interior. This edifice—a palace, temple and virtually impregnable fortress rolled into one—embodies the union of the spiritual and temporal powers of Tibetan Lamaism.

The Pule Temple—also known as the Temple of Universal Happiness—dominates the eastern hills. Its circular pavilion is reminiscent of the Temple of Heaven in Beijing. It houses an intricate dark-wood structure set on a marble base with a gilt bronze sculpture of a standing deity in union with his consort. Known as Tantra, this is one of the features of Tibetan Buddhism.

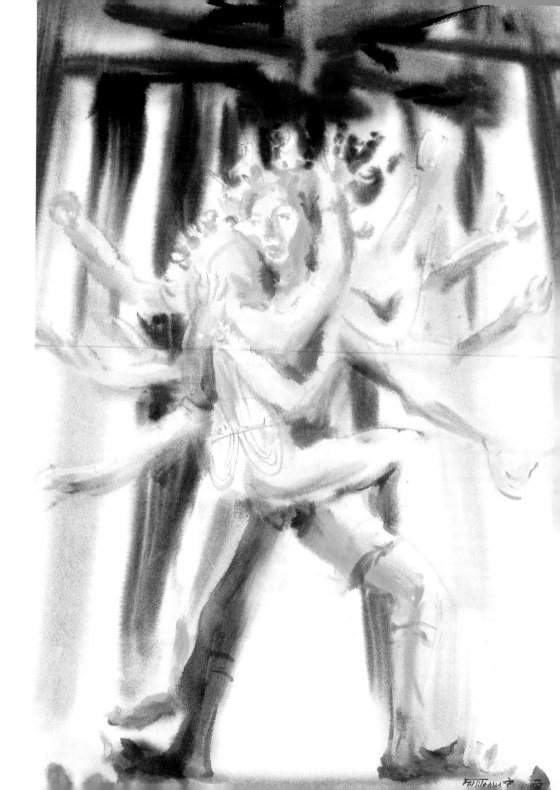

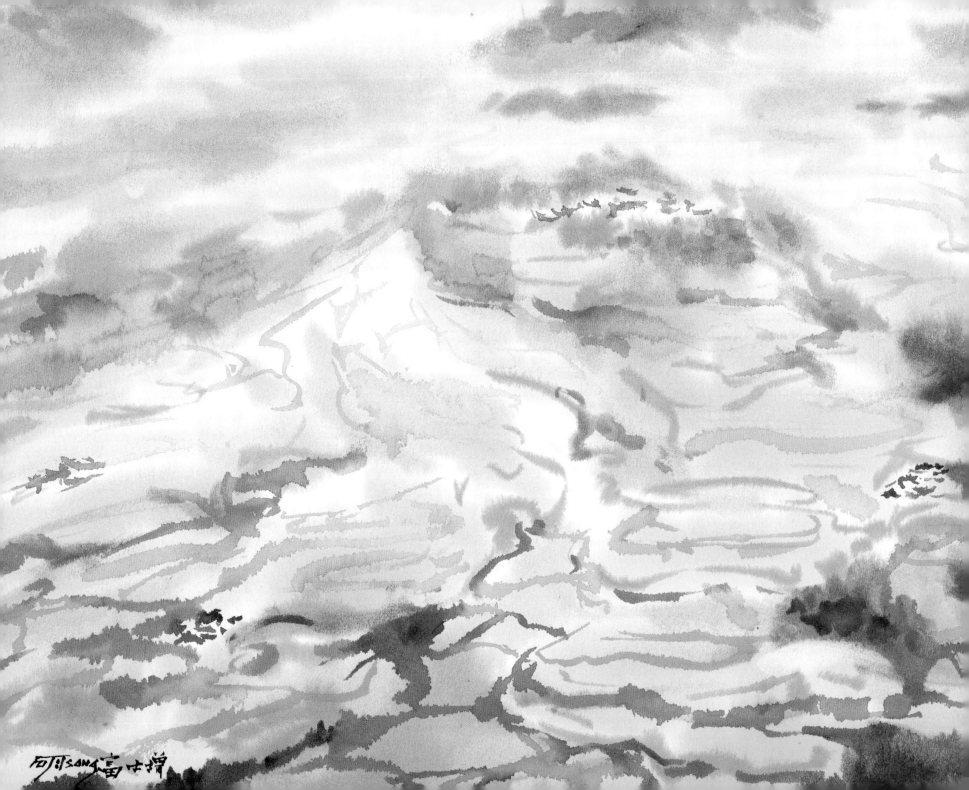

HUANGSHAN

Peak of inspired poets and painters

*No hill deserves my visit after I returned
from the Five Sacred Mountains, and the Five
Mountains do not deserve my visit after
I returned from Mount Huang (Yellow Mountain).*

So writes the great Chinese traveler, Xu Xiake, of Huangshan, the Yellow Mountain, which gives us some idea of the singular beauty of the site. It entrances me even before I set about climbing the peak. The surrounding countryside with its dark gray-roofed villages, scattered among lush vegetation and encircled by rice paddies, gradually gives way to hills covered with tea plants. Higher still, cascades and torrents gush forth in places, adding a splash of life to this peaceful, serene landscape with its giant bamboo forest. At the foot of the mist-enshrouded peaks, pines and firs of various shapes bid me a silent welcome. Clouds dance in a flitting ballet that reveals and conceals summits that are so strange in shape.

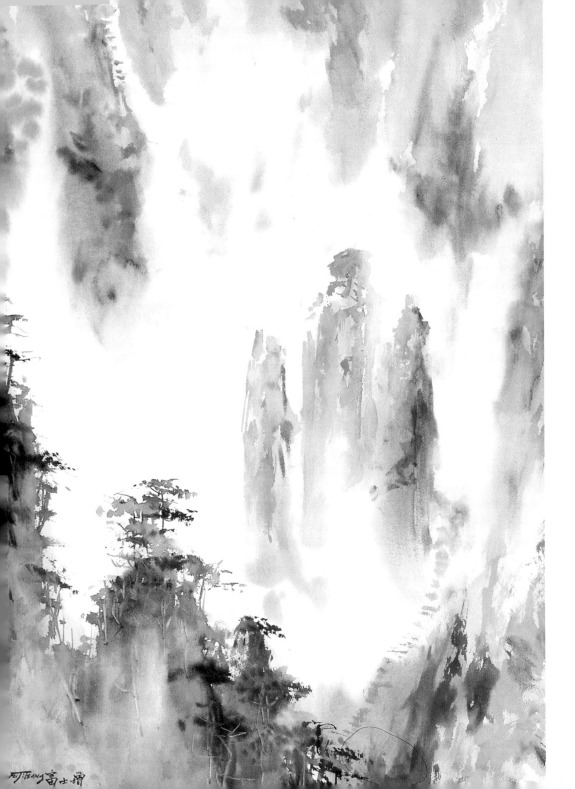

YELLOW MOUNTAIN, DEEP VALLEY, AND DIZZY PEAK
The small path of hewn stone descends
into a valley swathed in blue shadows,
only to reappear on the rocky ledge
of the slope opposite.
So many steps to reach the top!
In the distance, I hear the echo
reverberate in the valley.

Long ago the paths leading to the peak were carved into the rock. Some sections were little more than wooden stakes thrust into the cliff face, with only a rope providing a makeshift barrier between the sky and the chasm below. Fortunately, today there are three cable cars to whisk visitors in a hurry to the summit. These peaks with beguiling forms bear evocative names. An untimely spot of rain accompanies me as I ascend to a plateau facing the Celestial Capital Peak. The narrow stairway cut into the rock face disappears into the valley depths to be hidden by a veil of mist, and then reappears above the clouds in a fine line tracing its way to the summit. In the space of a few seconds, a ray of sunlight lends a striking contrast to the landscape, before being swiftly blotted out by a cloud and replaced by only the gray-blue sky. It is bitterly cold.

The Lotus Flower Peak rises to over 5,900 feet (1,800 m). It is not so much the altitude itself, but the path leading up, that is impressive. In places, it is only sixteen inches (40 cm) wide and edged with a small handrail. A breathtaking sheer cliff draws my gaze towards the depths of the valley.

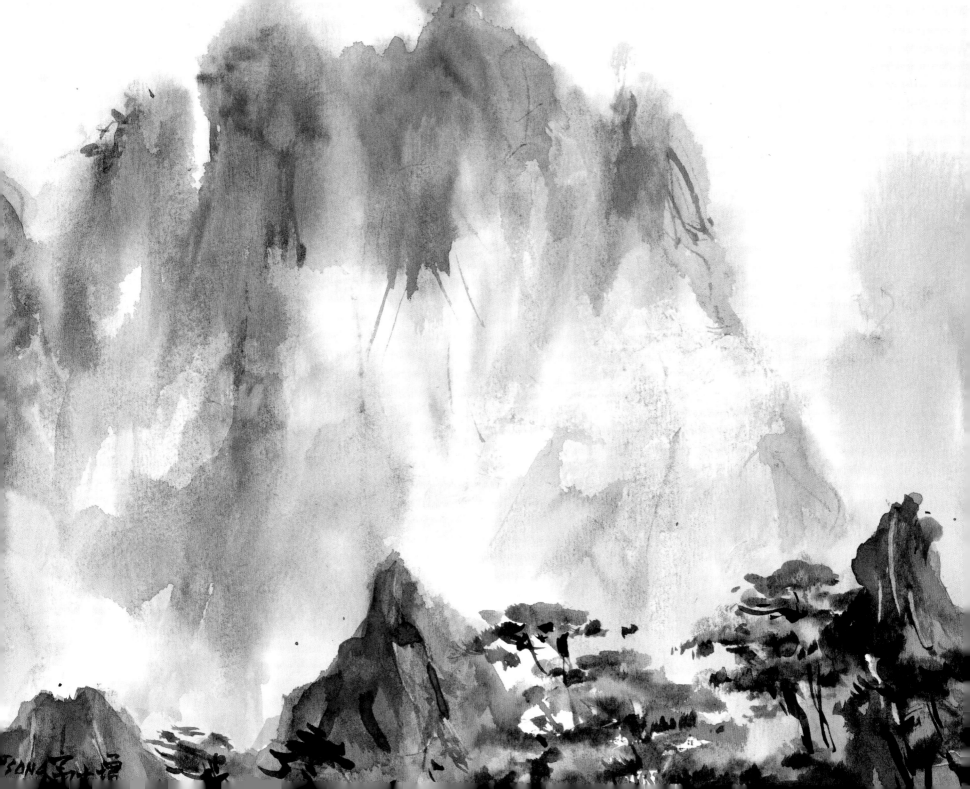

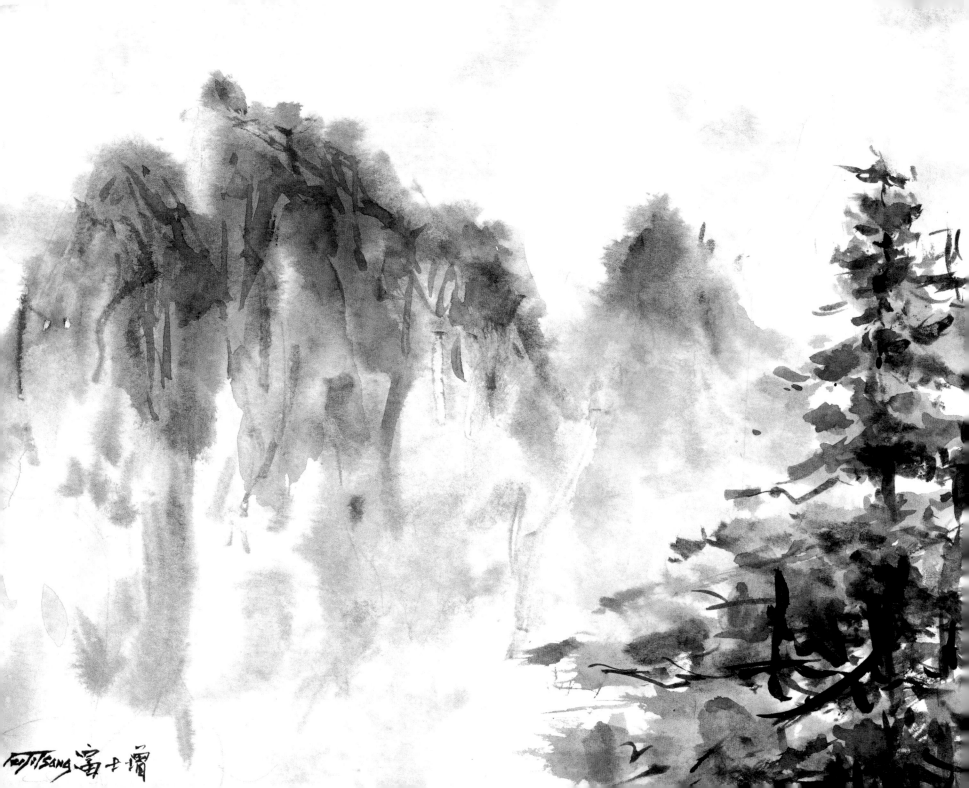

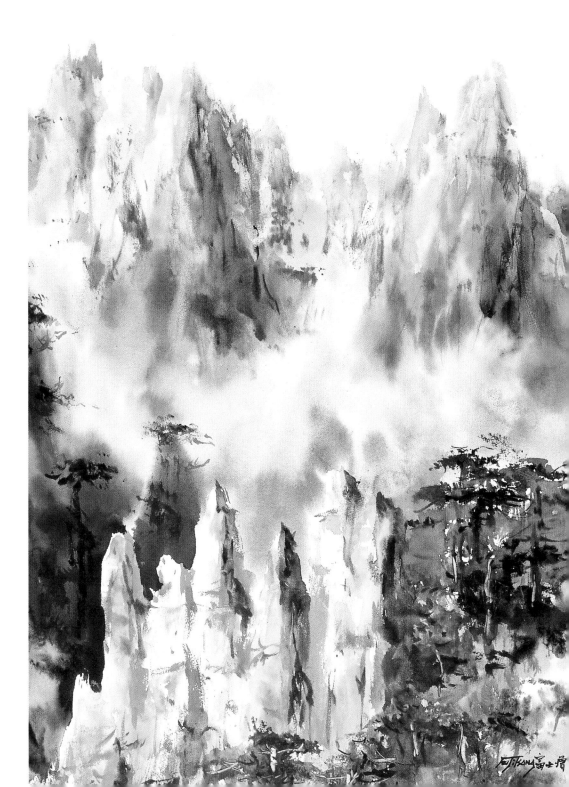

SUNSET OVER HUANGSHAN
Broad ocher crags, burnished
by time, each forming a stronghold
guarded by sentry-like pines that
cling perilously to rifts in the rock.
The straight, slender trunks
soar up towards the peaks.
The summits are flattened
by the incessant wind that
blows through the ridges.

The path winds its way through gnarled pines and jagged rocks. Added to the effects of the wind blowing through the peaks, the weight of snow and frost have given these pines the most astonishing shapes, probably providing inspiration to the first creators of bonsai. The peaks soar skyward, merging with the clouds. It is a perpetually changing and ever-unfinished masterpiece.

One of my favorite Chinese painters, Shi Tao, advocated seeking out strange summits that would serve as a base for sketching. A prince at the end of the Ming dynasty, he was persecuted by the Mongols, the new conquerors of China. Forced to hide in a temple, he became a monk. His painting, highly gestural and stylized, is quite different from the more sophisticated style of his peers. He favors pure lines in his compositions, evoking nature in an almost abstract manner with just a few dabs of ink and a couple of strokes. His "Eight Magical Scenes of Huangshan" portray the grandiose and elusive quality of this mountain.

Another master of modern Chinese art, Zhang Daqian, climbed the Yellow Mountain three times. This creator of

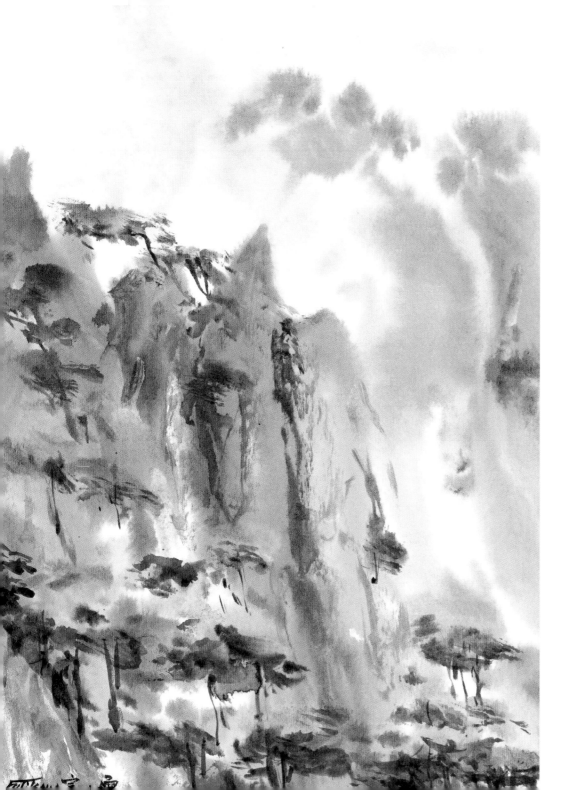

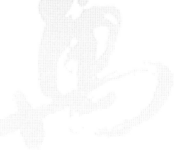

what is known as the "splashed-ink" technique would sometimes start painting by throwing bowls of ink and color onto rice paper. He would then transform these random splashes into mountains, valleys and waterfalls. Perhaps it was the power of these landscapes that gave these painters so daring a sense of creativity? How many times will I come to this enchanted place? I have no idea. Yet the vision of this mountain remains within me, and I will return to it as long as I live.

To the Chinese mind, nature is the greatest of masters. I like to paint surrounded by nature in order to capture the fleeting moment and to feel the emotion conveyed by the elements. The conditions are not always the best, but the sensations and emotions are overwhelming! Sitting on the ground, I try to commune with nature and to follow the dance of cloud and peak. The only way to depict this is through one's own dance with painting, casting aside brushes, colors and medium.

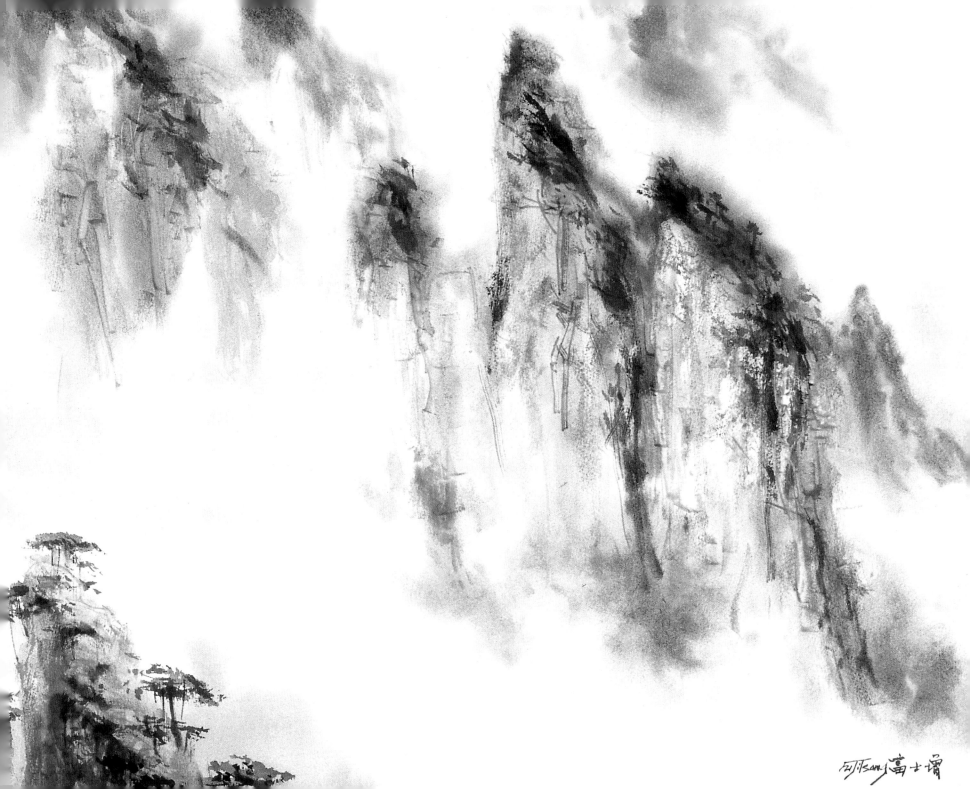

周庄 ZHOUZHUANG
China's first water village

Beautiful is the lakeshore
after rain; beneath
the bridge, a cool breeze
blows sweetly; two cranes
and my small boat, three
companions late at night
in the moonlight.

"IN A SMALL BOAT AT NIGHT" BAI JUYI
From: Alley, Rewi (tr.).
Bai Juyi 200 Selected Poems. Beijing,
China: New World Press, 1983, p. 257.

中國第一水鄉周庄
古鎮景色美
雙橋天下聞

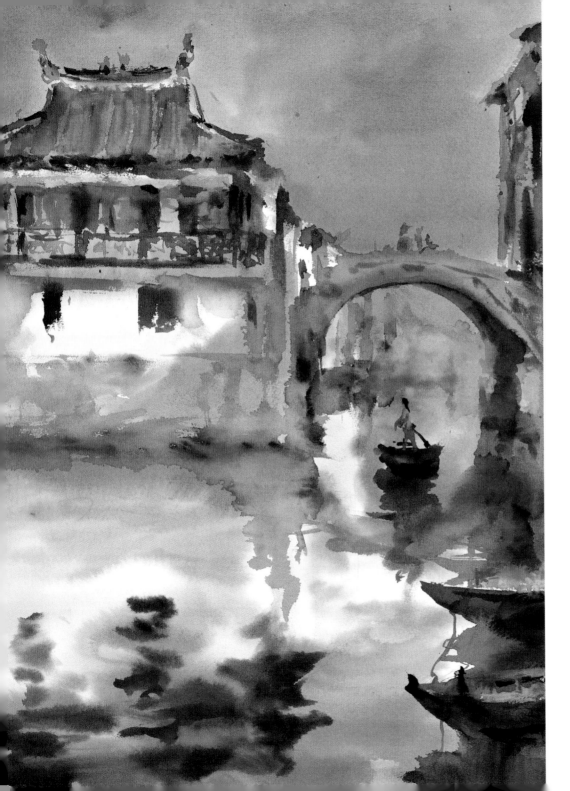

Encircled by canals and lakes, Zhouzhuang deserves to be called the little "Venice of China." Artists, the literati, and aristocracy have long enjoyed meeting in the musical atmosphere of its teahouses nestled along the water's edge. It is also a good place for a stroll. With its two-storied houses belonging to dignitaries, the village boasts some picturesque architecture. Refined yet convivial, the successive courtyards of the houses mark the boundary between public and private life. This village has a delectable history that is highly symbolic. In the thirteenth century, the Zhou family—from whom the village got its name—formed the first settlers in this region traversed by rivers and dotted with lakes. The land was fertile, with fish and shellfish in abundance. The members of the tribe prospered and their reputation of being kind and generous Buddhists spread throughout the region. Seeking to take advantage of such generosity, more and more people came to settle in the vicinity. The Zhou family donated a large piece of land for the building of an imposing temple, where a master of great renown delivered his teachings. So great was this temple's reputation for magical and spiritual powers that mercenaries and bandits would avoid the region for fear of retaliation. This place is imbued with the spirit of those who have lived there, a presence which lends an even greater magic to the natural setting.

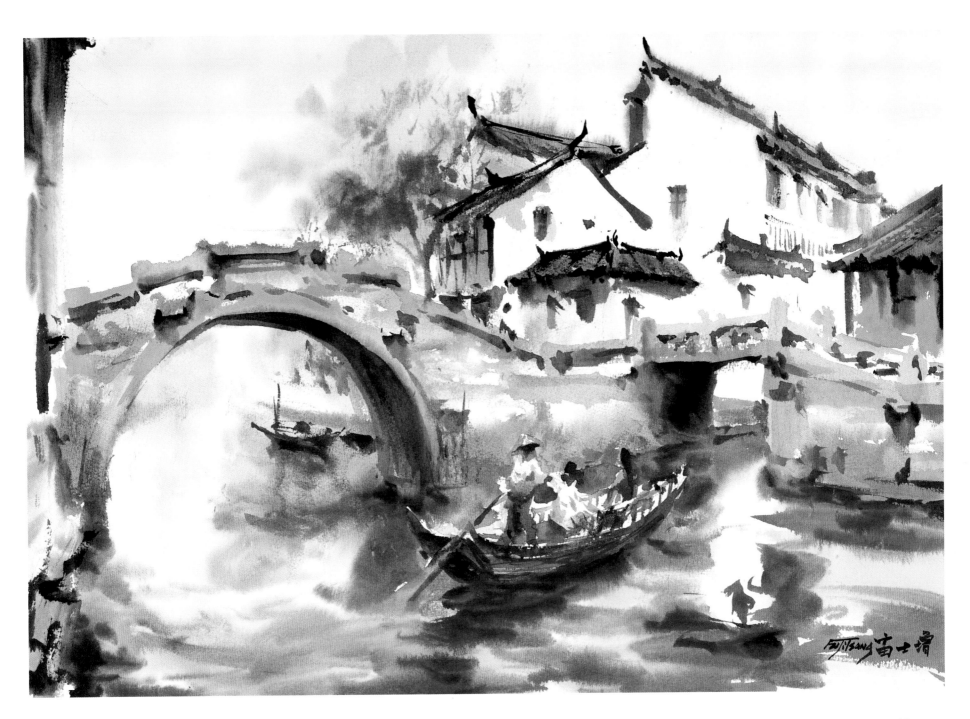

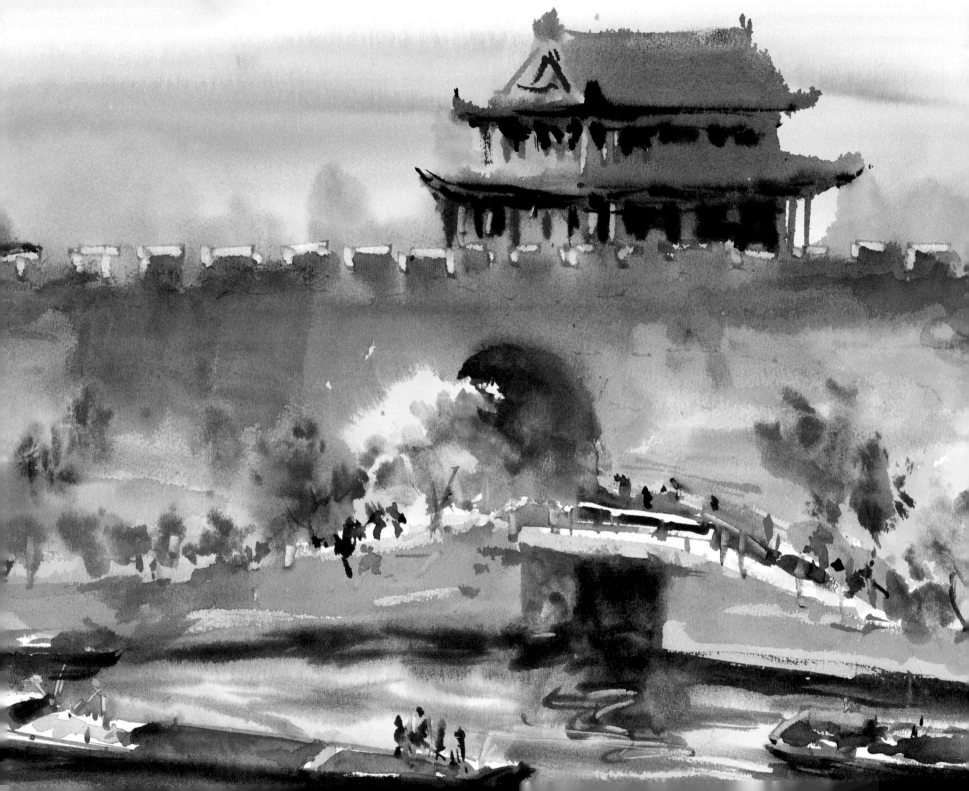

THE SUZHOU AND HANGZHOU REGION
Land of water and canals

IMPERIAL CANAL IN FRONT OF THE SUZHOU RAMPARTS (FACING PAGE)
Dug over a thousand years ago, this canal,
six hundred and twenty miles (1,000 km) in length,
links the two longest waterways in China:
the Yellow and Yangzi rivers.
It flows alongside the ramparts of the old town in Suzhou.

Suzhou, one of the oldest towns in the Yangzi Basin, is known throughout the world for its gardens and canals. In the fifteenth century it boasted over a hundred gardens. The gardens of Suzhou perfectly exemplify the beauty of the Chinese garden. I have visited them in all seasons and all weathers—they never lose their charm.

The "Humble Administrator's Garden" dates from the sixteenth century and covers five hectares. It is the most beautiful of Suzhou's gardens. In spring, flowering azaleas provide pockets of vivid and varied hues. In summer, a boat-shaped pavilion with windows at each of its four corners seems to drift along on a pool filled with sweetly fragrant lotus flowers. On a hillock stands a summerhouse whose roof tips curve gracefully upwards; in the fall it is surrounded by a fiery blaze of red maples and multicolored chrysanthemums that are associated with mid-fall festivities. In winter, a thin layer of hoarfrost coats the rockeries with their variously shaped stones, while burning coals glow in a bronze brazier inside the reading room. On the windows, wooden

Blossoms fall into the current, dyeing the depths and shallows red;
All day long sailboats fly among these embroidered waves.
Mulberry leaves, like tiny squinting eyes,
suffer from the drought;
The wheat's whiskers, long buffeted,
can withstand wind now.
Cow and sheep paths blur
and merge with a thousand mountain peaks.
A single road stretches to this village
where cocks and dogs hide.
It wouldn't take much space to plant
five willow trees for yourself here,
so why bother dashing on
your nonstop journeys?

"ON THE ROAD TO HANGZHOU" FAN CHENGDA
From: Schmidt, J.D. Stone Lake
The Poetry of Fan Chengda,
1126–1193. Cambridge:
Cambridge University Press, 199, p. 106.

45

screens form a latticework like cracked ice, thus serving to emphasize the contrast between the harsh conditions without and the coziness within.

The area dedicated to bonsai reveals the aesthetic of the Chinese mind: beauty is born of simplicity rather than opulence and superfluous clutter. Many varieties of dwarf trees are kept here, some of which are several hundreds of years old. Careful pruning and the use of a few stones and a little moss to control the way in which the tree grows and develops gradually give rise to a form suffused with poetry and a composition of great harmony. The symbolic power of suggestion and evocation is far greater than that of direct portrayal. This aesthetic idea remains valid in the context of painting. It is easy to provide a faithful copy of reality. Personal interpretation, on the other hand, requires time, energy, humility, and perhaps a dash of genius!

The "Master-of-Nets Garden"—an allusion to its owner's lack of interest in worldly affairs—is one of my favorites. Though tiny, it is as exquisite and precious as a gem. The entrance gateway, built of gray brick carved with floral motifs and figurines, sets the tone of refinement from the start.

Two successive courtyards frame two chambers, one of which is exclusively for men and the other

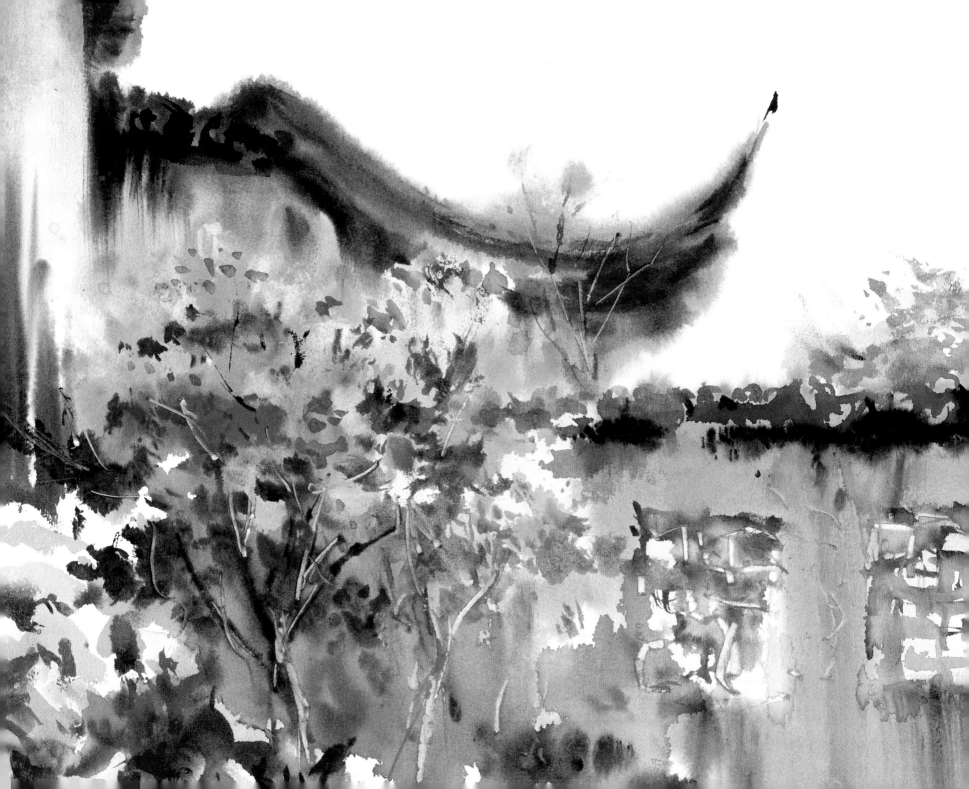

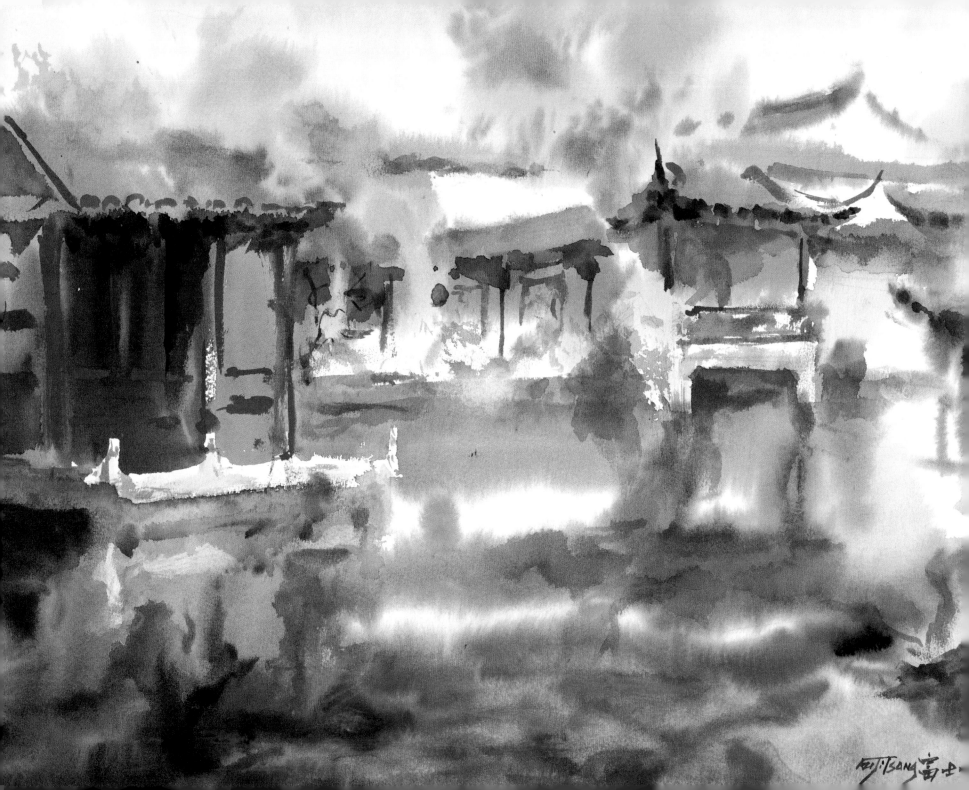

LOTUS POOL IN THE HUMBLE ADMINISTRATOR'S GARDEN
The lotus is one of the favorite flowers of the Chinese. Although its roots are sunk into mud, its blossom is unsullied— the symbol of spiritual purity.

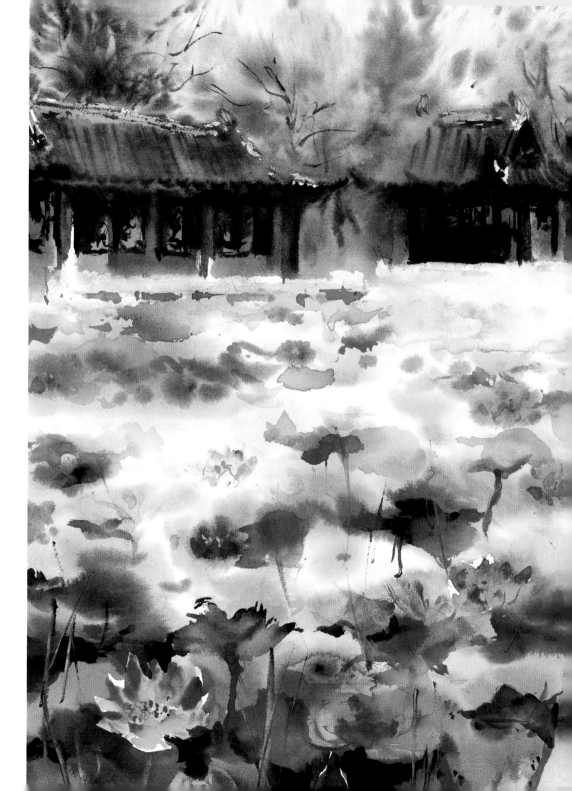

for women. The rosewood Ming furniture is of a sober elegance, evocative of this era that was to influence the Art Déco style in Europe. I have often lingered in the covered walkways that run alongside the pond. I never tire of admiring the compositions akin to living paintings that result from the rocks set against walls whose openings frame a broad-leaved banana tree or a flowering plum. I marvel at such a wealth of detail in so small a space: at each season, every bend and viewing angle, this garden is different and so attractive.

Tiered dwellings are characteristic of the Tongli garden, with its quietly poetic name of "Garden of Retreat and Reflection." They afford a wide view down over the garden and, when observed from the water's edge, their architecture adds surprising charm to the landscape. I came across the following verse in calligraphy in one of the reading rooms: "the mountain need not be high as long as it is home to an immortal; water need not be deep as long as there is a dragon." A wonderful garden can be had simply by emphasizing the two essential natural elements—Mountain

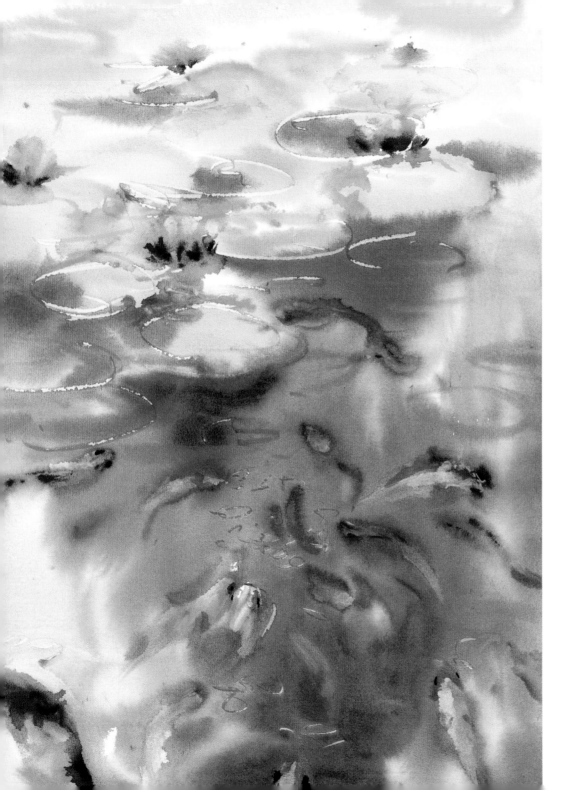

and Water. The music pavilion is reflected in the water's looking glass. I can just imagine the literati of old writing poems here, inspired by the landscape and savoring a goblet of wine. Legend has it that in one garden that was home to a famous meandering waterway, these poets would station themselves along the banks. Each poet had to find a verse that rhymed with the previous one just as a miniature boat sailed before him. If inspiration failed him, he was made to drink the goblet of wine. What delightful evenings of poetical inebriation they must have been!

Capital of the Song dynasty, Hangzhou is one of the few Chinese cities that has managed to preserve its charm in the face of urbanization. The way of life there remains tinged with the mellowness of this era so famous for its refinement. The city is bordered by the great Xihu (West) Lake. Strolling along its shady banks or drifting on its turquoise waters, it is easy to forget the metropolis with its some two million inhabitants. A causeway with white marble bridges crosses the lake like a silken sash set with precious stones. Nestling on a nearby verdant hill often swathed in

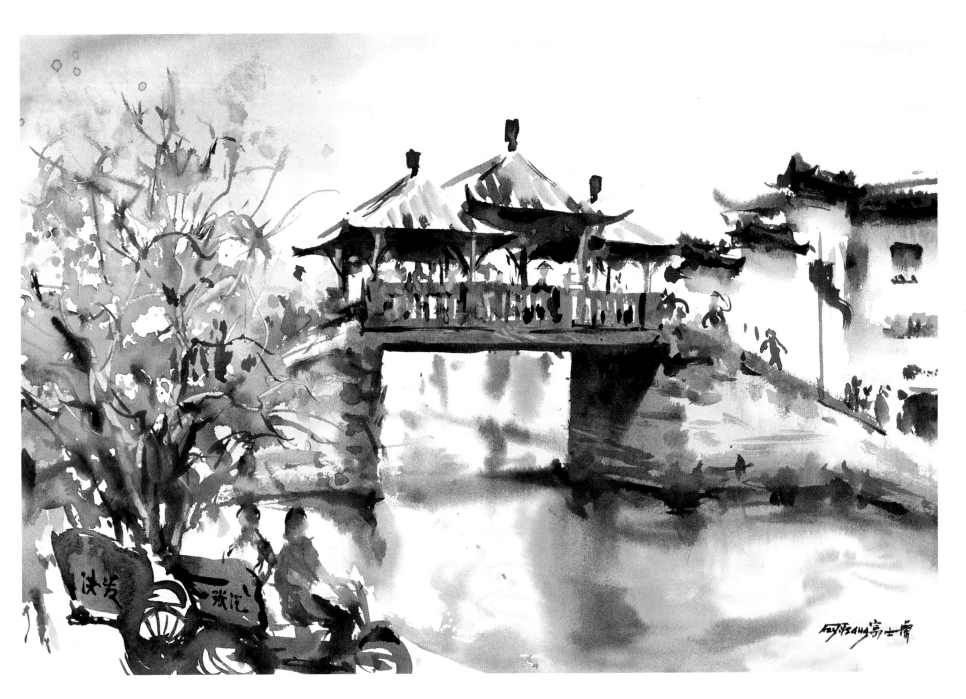

51

 THE SUZHOU AND HANGZHOU REGION
Land of water and canals

WEST LAKE AT HANGZHOU (FACING PAGE)

light mist is Lingyin Si, the Temple of the Soul's Retreat. Built in 326, it has been destroyed fifteen times. The last occasion, during the Cultural Revolution, proved almost fatal. Former prime minister Zhou Enlai, the generous benefactor behind the previous restoration, intervened to prevent the temple from being laid to ruin by the Red Guards. I love the peaceful atmosphere of this place. I follow a stream on the mountainside with its array of sculptures and bas-reliefs housed in damp caves, partially covered by cork oaks and vegetation. The awesome temple buildings at the heart of a forest of giant trees exude a harmony that is both soothing and serene.

Long Jing (Dragon Well) tea is one of the region's specialties. Young shoots, picked in the spring, are the most highly prized for their toothsome flavor. The quintessence of the tea's subtle aroma and sweet pungent taste is fully revealed during the tea ceremony. For the discerning connoisseur, pure water and an earthenware "Purple Sand" teapot (known as *zisha* in Chinese) offer the promise of sheer pleasure.

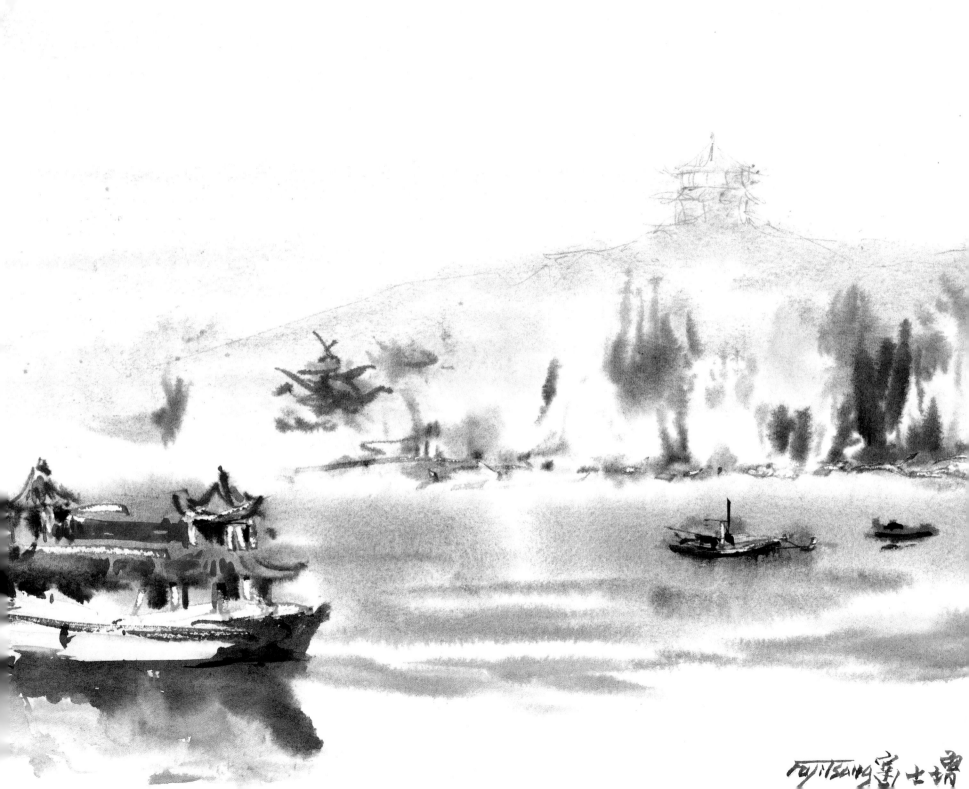

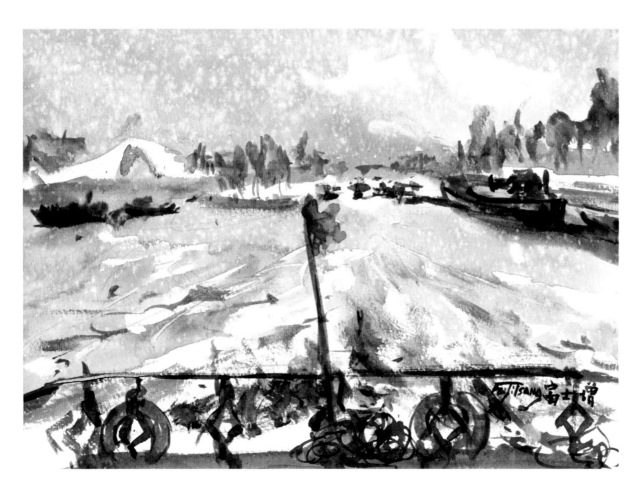

GRAND IMPERIAL CANAL

The Grand Canal is a complex work of locks and
ramifications. Strings of flat-bottomed boats,
over a hundred feet (30 m) in length,
ply the waters, among the dense traffic
of small sampans.

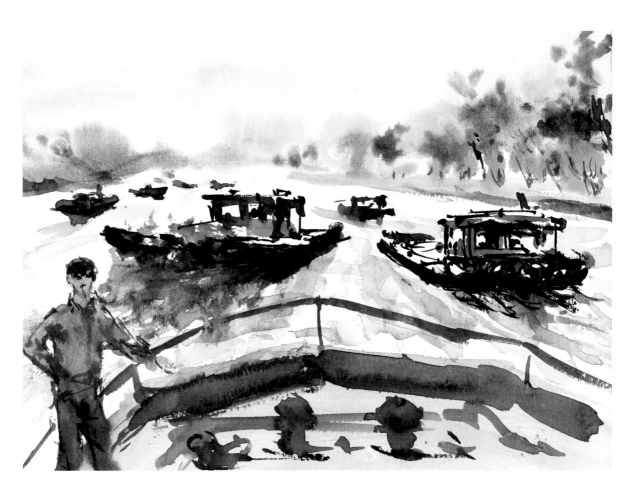

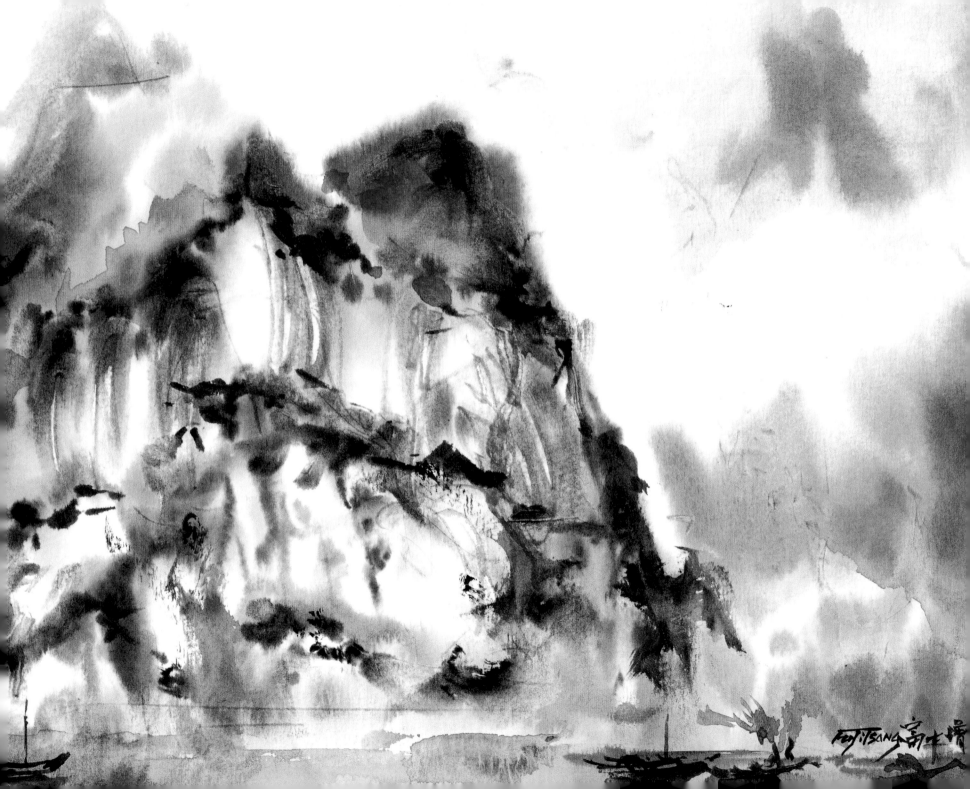

STONES
From nature to painting

I climb the road to Cold Mountain,
the road to Cold Mountain that never ends.
The valleys are long and strewn with boulders,
the streams broad and banked with thick grass.
Moss is slippery though no rain has fallen;
pines sigh but it isn't the wind.
Who can break from the snares of the world
and sit with me among the white clouds?

HAN SHAN
From: Watson, Burton. Chinese Lyricism, Shih Poetry from the Second
to the Twelfth Century. New York: Columbia University Press, 1971, p. 178.

Only the stone on the hilltop,
its months and years too many to count,
knows nothing of the four-season round,
wearing its constant colors unchanged.

Lu Yu
From: Watson, Burton (tr.). The Old Man Who Does As He Pleases:
Selections from the Poetry and Prose of Lu Yu. New York and London:
Columbia University Press, 1973, p. 42.

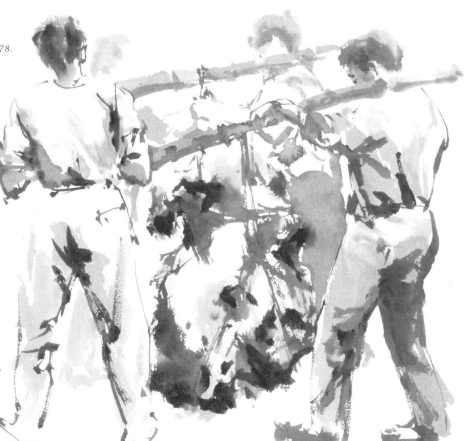

WORKERS TRANSPORTING A ROCK
TO BE USED IN A GARDEN LAYOUT

Like the *Wenren*—these men of letters of days gone by—
I have a love of stones and rocks. Could it be hereditary?
I take great delight in contemplating and handling such
stones, all quite different in shape, color and origin.

Chinese philosophers regarded stones as living beings
akin to animals, plants, and man. Like them, stones are the

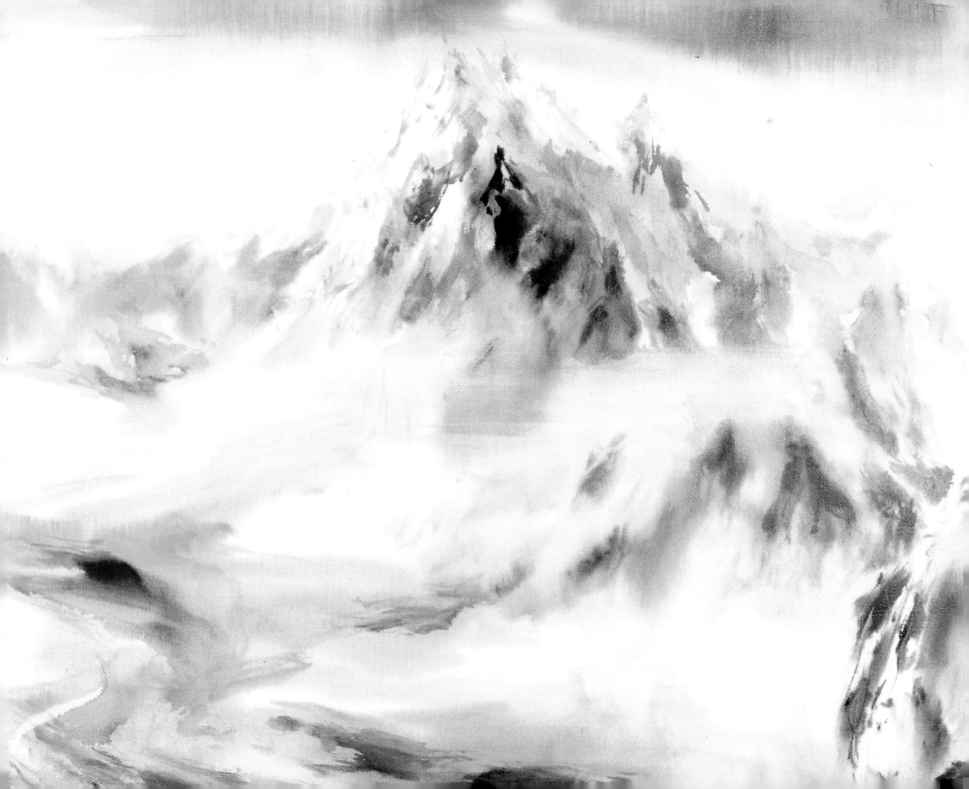

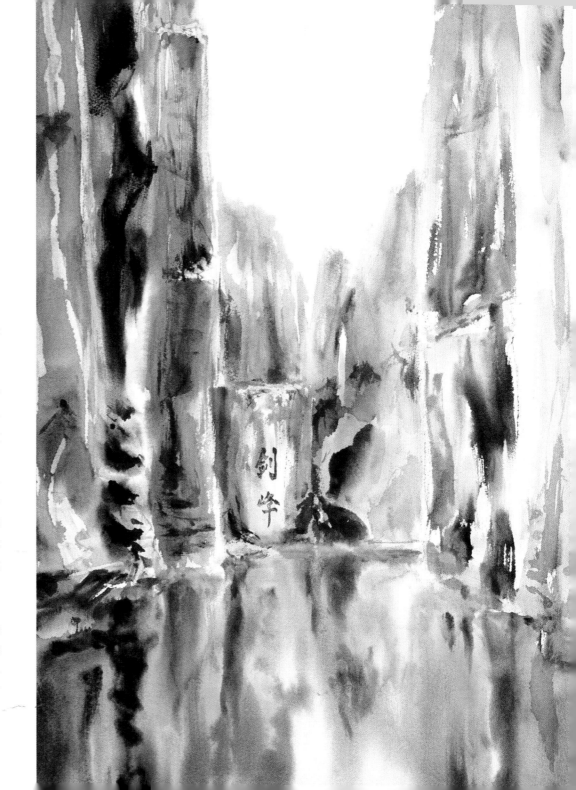

STONE FOREST AT KUNMING
Nature is a patient sculptor.
It has fashioned these rocks to create
a forest of peaks and labyrinths.
Learned men of old would use
them as an aid to inspiration.
Wherever one looks, calligraphy
has been etched into the rock faces.
As all Chinese paintings are
duty-bound to carry a calligraphic
inscription, these masterpieces
have been signed by many famous men.

work of the elements and represent the Macrocosm. Both man and stone must suffer the test of time. If their intrinsic nature is good enough, they may become venerable, even immortal. The Legend of the Monkey King, with which all Chinese children are familiar, is symbolic in this sense. For years too numerous to mention, a rock on a mountaintop was impregnated with celestial light and dew. One day, it opened when struck by a thunderbolt. A stone monkey with magical powers and a quick-tempered character was thus born. Buddha made him the first disciple of the monk Sanzang, who traversed mythical lands and braved all kinds of creatures in order to bring the Sutras or sacred Buddhist texts back to China. This legend, inspired by the real life of this Buddhist master, may be found in the famous classic Chinese novel *Pilgrimage to the West*.

Throughout China, mountains and their summits have been compared to living beings. The cult of rocks and stones probably stems from the beauty of this matter, so evocative of the perpetual changes of the "ten thousand things" issuing from the Tao.

GARDEN OF RETREAT AND REFLECTION (LEFT)
This view's picturesque composition
includes many of the essential elements of
a Chinese garden. The judiciously placed rock,
mural opening and maple form a tableau
that sets off the architecture.

THE THREE YANGZI GORGES (FACING PAGE)
This grandiose site with its turbulent
currents and awesome vertical rock faces
is to be swallowed up in the waters
of the world's largest dam, currently
under construction on this river.

One of the most imposing stones is found in the Summer Palace to the north of Beijing. It was discovered by a Mandarin Chinese collector. At the time, he had to wait for winter in order to be able to slide it onto an icy road to transport it to his mountain abode. It had cost him the whole of his fortune, but he was finally forced to abandon it in a field. It thus became known as the "rock of ruin." One day, the emperor Kangxi was passing by and fell under the spell of this stone furrowed and sculpted by time. Heedless of the curse weighing down upon it, the emperor had the stone conveyed to his palace, where it stands in the reading room courtyard facing the lake. Could it possibly prevent evil spirits from crossing the threshold in the same way as entrance walls in Chinese houses? Some stones—known as "dream-stones"—are like pictures. Images can be seen in their veins similar to Chinese paintings with landscapes and figures midway between imagination and reality. Stones are carved by carefully selecting the cutting angle so as to bring out the most evocative motifs. Dali is the region best known for such dream-stones.

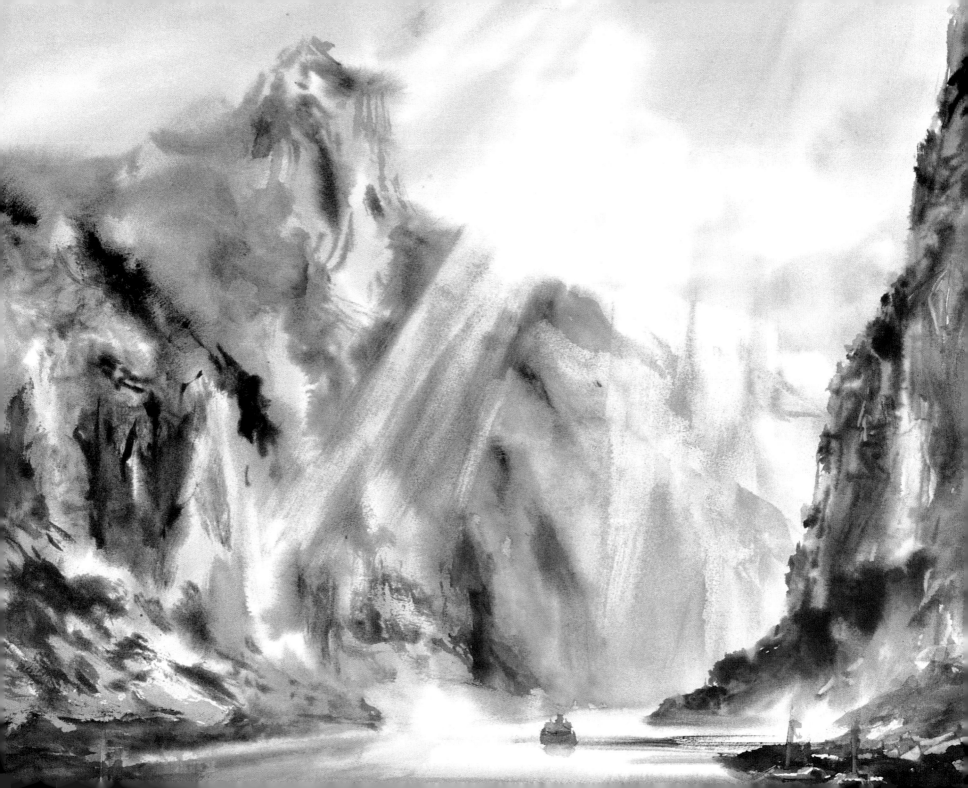

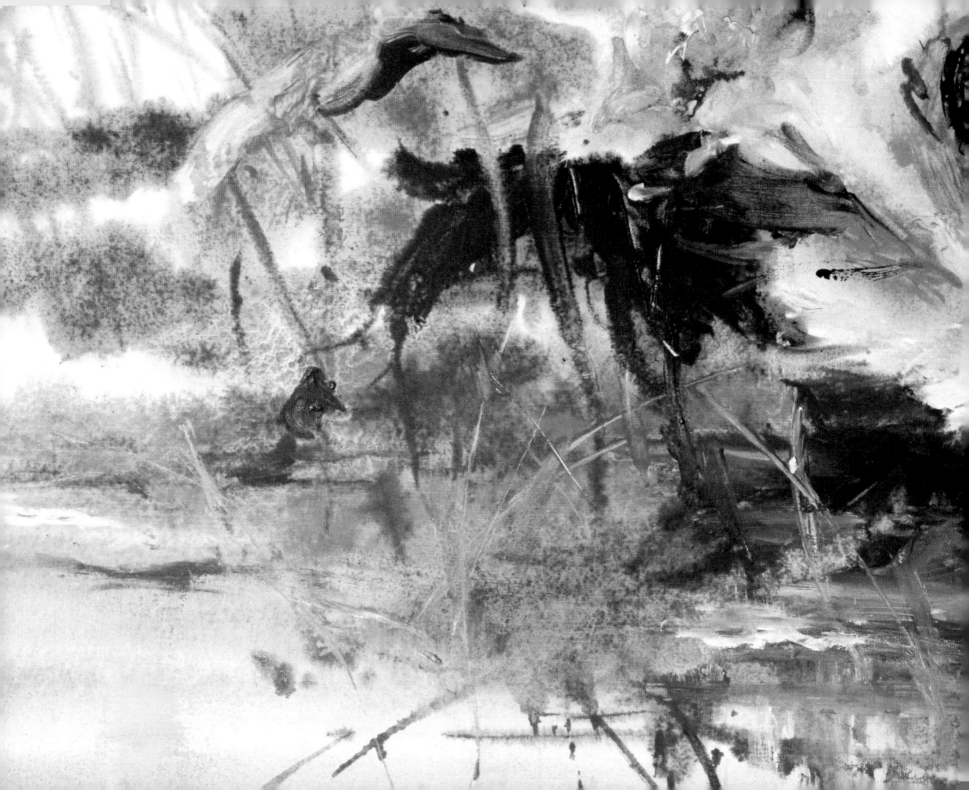

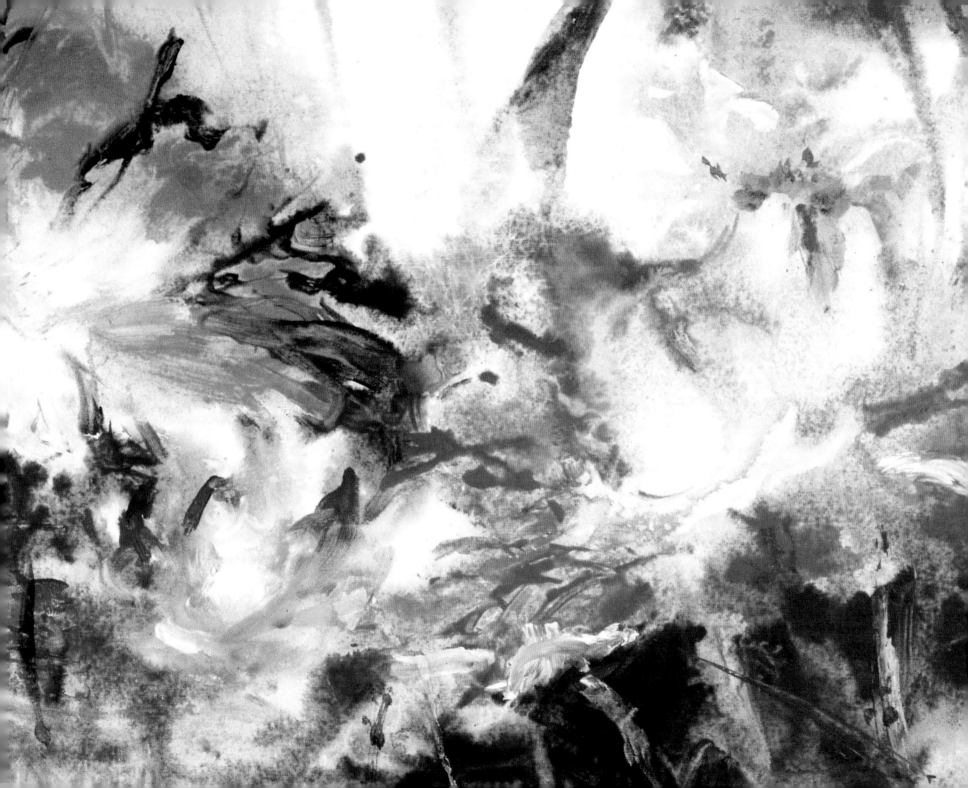

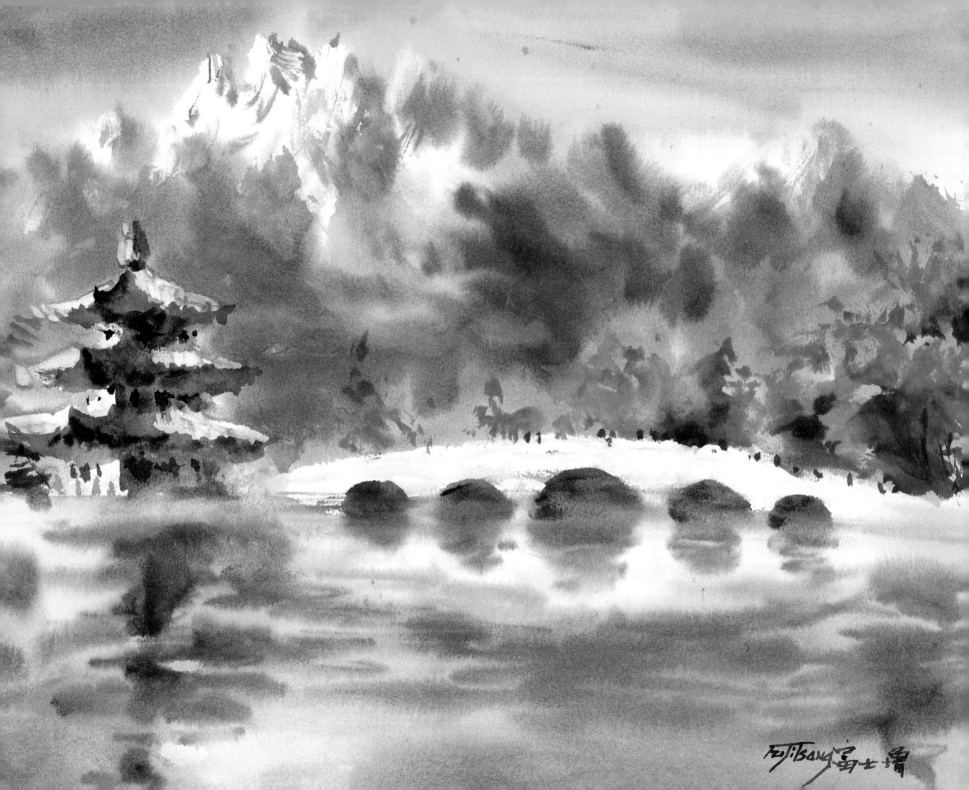

LIJIANG, DALI, AND KUNMING
Timeless regions

Why do I live among the green mountains?
I laugh and answer not, my soul is serene:
It dwells in another heaven and earth belonging to no man.
The peach trees are in flower, and the water flows on....

"IN THE MOUNTAINS" LI PO
From: Obata, Shigeyoshi (tr.). The Works of Li Po, the Chinese Poet.
New York: Paragon Book Reprint Corp., 1965, p.73.

JADE DRAGON MOUNTAIN (FACING PAGE)

According to a Chinese legend, in the Celestial Palace there is an orchard whose fruit will make man wise and immortal. Chinese men of letters, who dreamed of discovering this enchanted place, named it the "Timeless Orchard." I feel that I may have found it in the region of Lijiang, located in the foothills of Tibet, the "roof of the world." Shielded by the Jade Dragon mountain range and fed by the snowmelt of the glaciers, Lijiang is home to various ethnic minorities—Tibetan, Han, Naxi, Bai, and Thai. As such, it has an atmosphere all of its own. Beautiful without

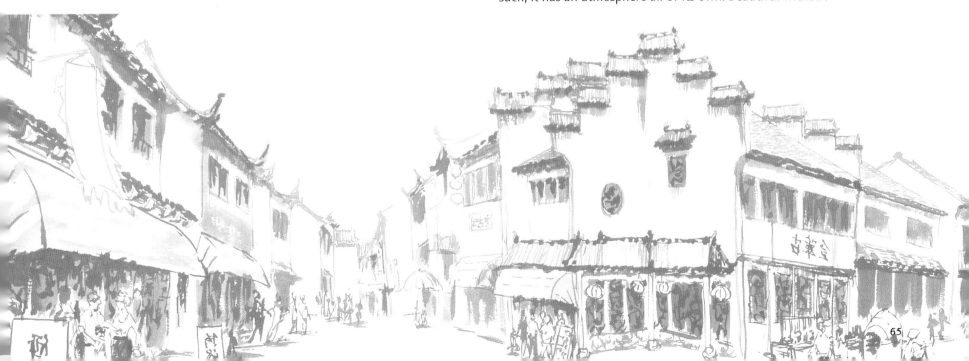

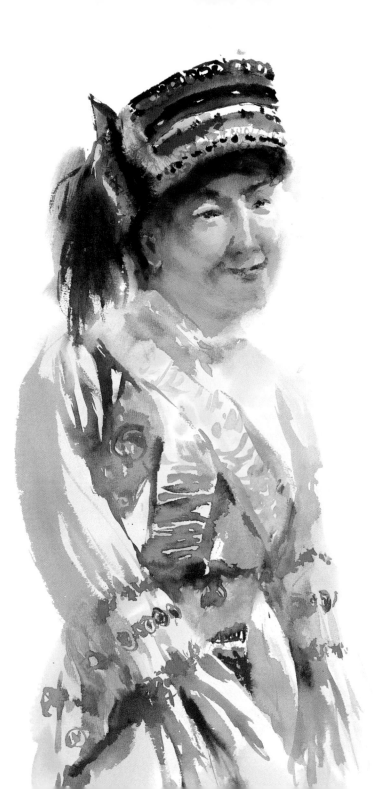

being sophisticated, rich without being gaudy, it is like no other Chinese town. It is no coincidence that legend locates the earthly paradise of Shangri-la in the same region.

The Jinsha (Golden Sand) River forms one of the tributaries of the Yangzi. Some forty-three miles (70km) from Lijiang, the Hengduan Mountains—literally meaning "cut across"—block the course of the river. The current quickens in narrow ravines, known as Tiger Leap Gorge, swirling into eddies and waterfalls. When I was there, a road was being built, hewn into the cliff face. Struck by the vastness of these sheer, almost vertical mountains and the desperate efforts of these men to tame nature, I was overcome by a sense of how fragile life is. A little further, on the outskirts of a charming village whose name, Baisha, evokes white sand, there is a very old house. Its sophisticated architecture stands in marked contrast to the pure lines of the surrounding Jade Dragon Mountains with their snow-capped peaks. Lying on the trading routes between Tibet, Nepal, Indochina and China, this village enjoyed a glorious past, with the coexistence of different communities and various religious practices. This is apparent in the murals adorning

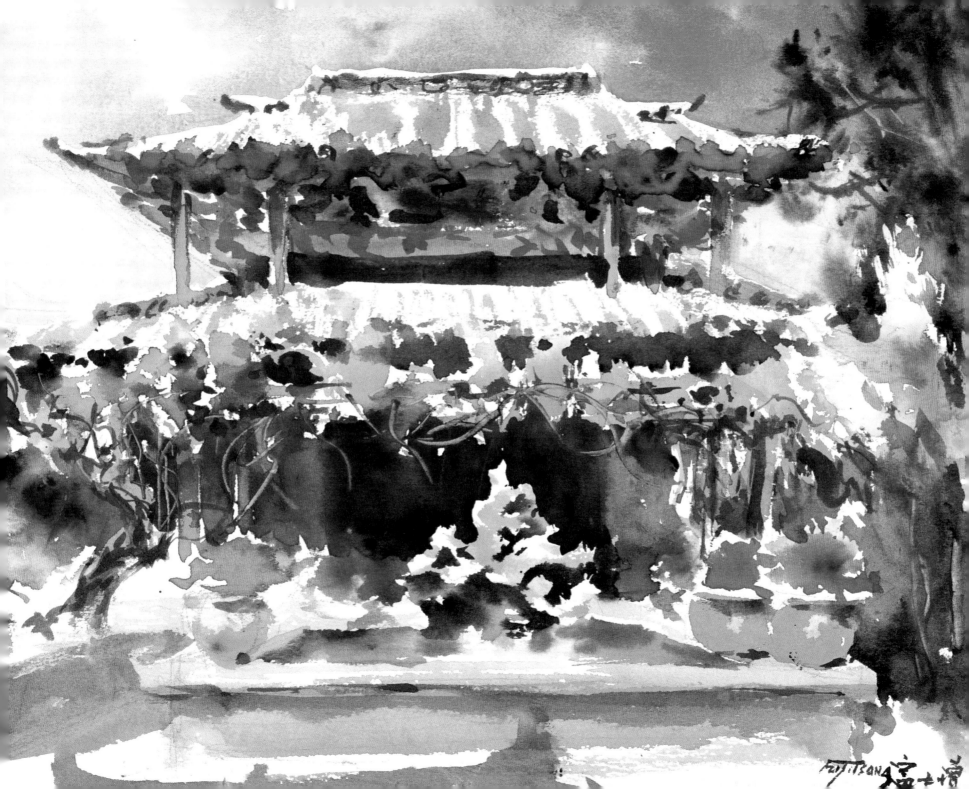

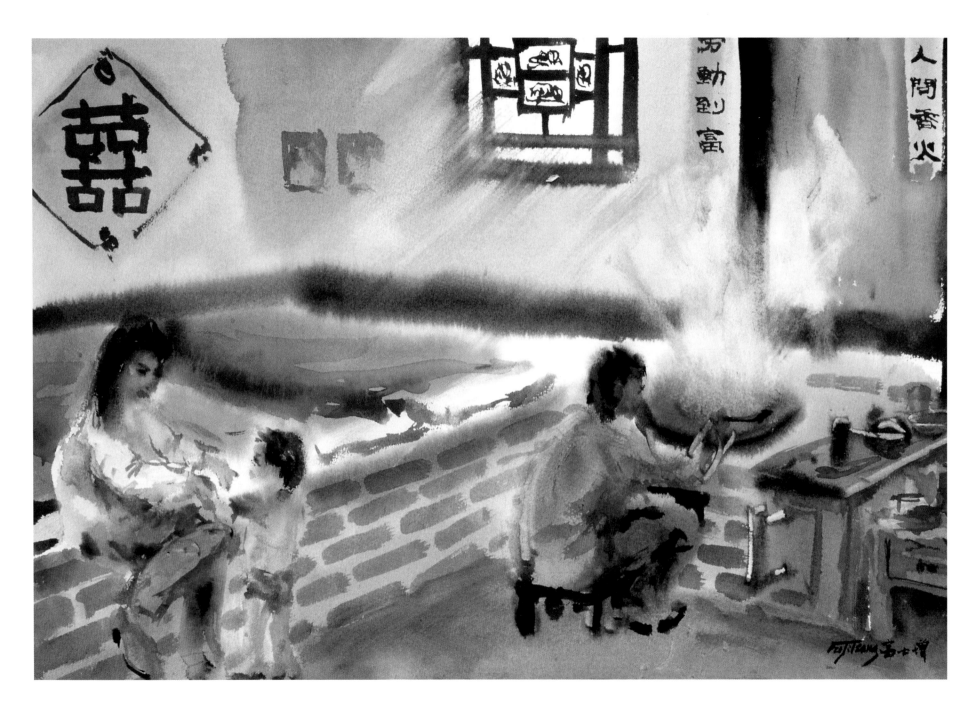

the walls of the main temple, where Taoist, Buddhist, Lamaist and Confucian figures stand side by side with Dongba deities, gods of Naxi rites. It is certainly a fine example of tolerance and harmony for our own age!

In another village, the inhabitants come together, once the harvest is over, to help one of the village families to build their house. The house is rectangular in shape and is constructed around four sets of pillars. When these pillars have been erected, several people climb them to attach the crossbeams. The walls are then raised using large bricks made from a mixture of sun-dried earth and straw. The house has three rooms; the walls are neither coated nor colored, and the floor is of beaten earth. The middle room forms both the living room and kitchen. The two other rooms are used as bedrooms, with beds made of brick taking up half of the available space. Meals are eaten on these beds. The villagers tell me that the basic structure of such a house can be created in a few days. Tradition has it that the owners of the house provide the finest food to those who participate in its construction so that they will do a good job. When the work is complete, the entire village celebrates.

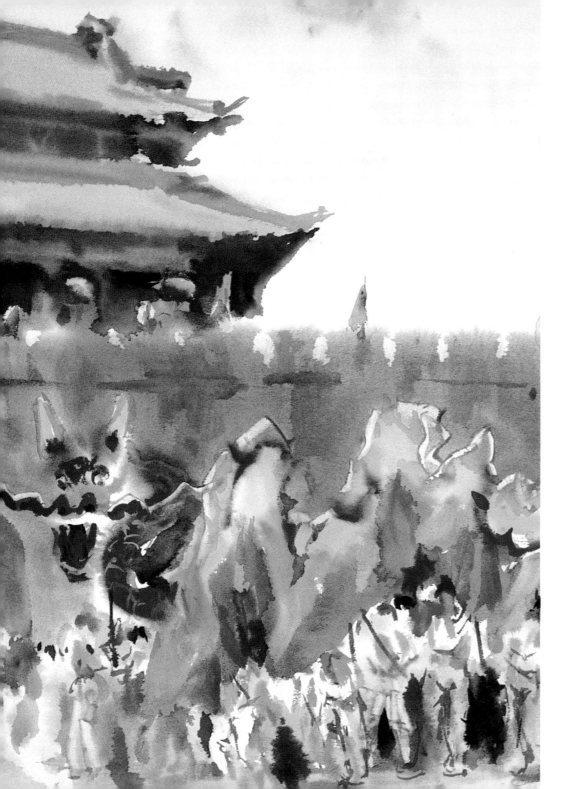

Meanwhile, in big cities such as Beijing or Shanghai, buildings spring up like mushrooms. What a striking contrast between such upwardly-mobile cities and these rural regions that retain their ancestral character!

Further south lies the city of Dali, the long-time capital of the powerful Nanzhao kingdom that ruled the entire province of Yunnan from the eighth to thirteenth centuries. The inhabitants—mainly Bai—wear colorful costumes and silver jewelry that is both modern and refined in style. During a local festival, I saw people from the surrounding area come down from the mountains and gather at the old city gates to watch the "dragon dance." The head dancer conducts the movement by means of a multicolored ball mounted on a stick, which he brandishes before the beast brought to life by a dozen young men draped in fabric of a variety of hues.

A few miles from the city, set against snow-capped peaks, the Three Pagodas Temple looms up into the stormy sky. A wide avenue strung with vividly colored banners leads to the central building. The three pagodas, light in color and slightly rounded in silhouette, soar skyward with a southern grace.

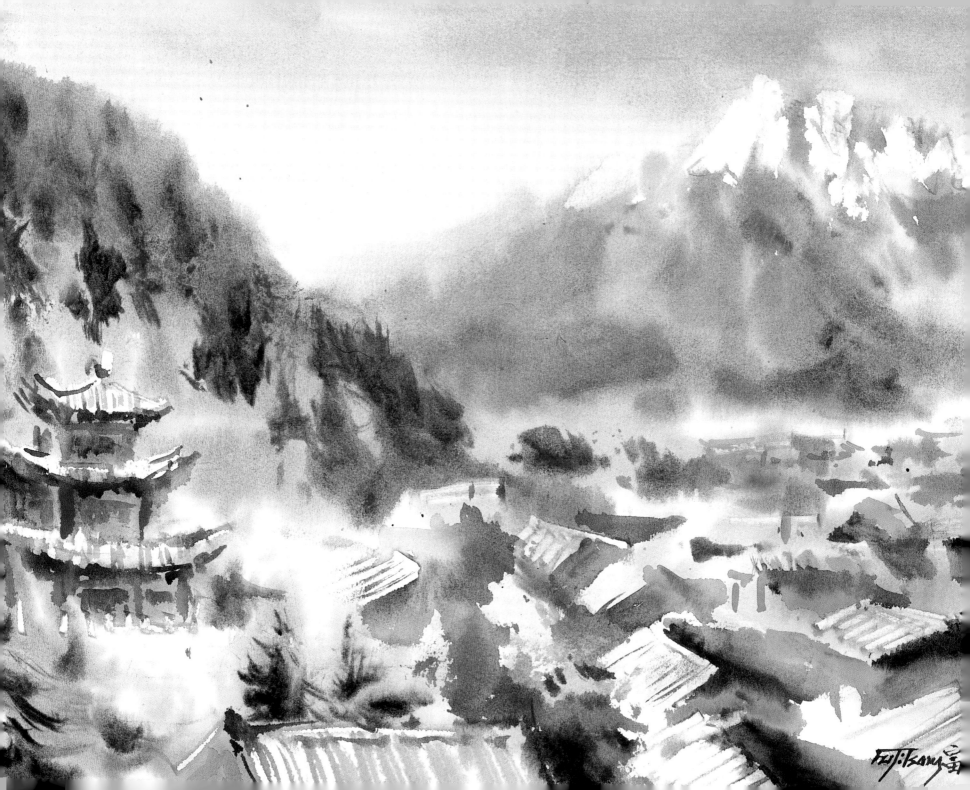

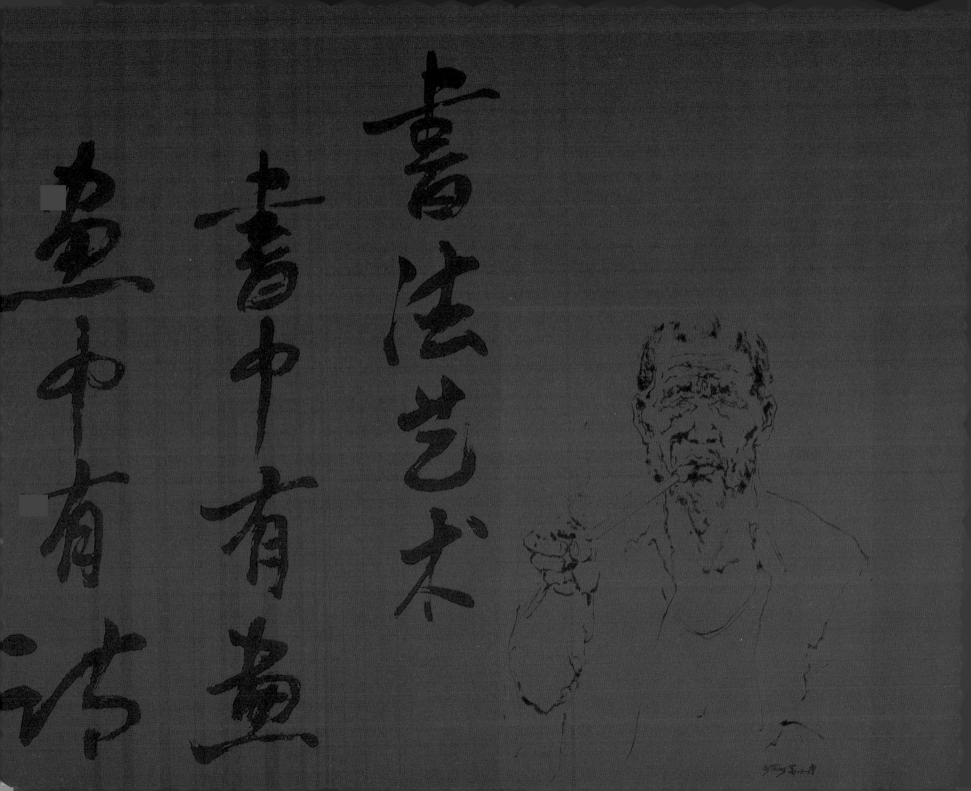

CALLIGRAPHY
Painting in writing

"Painting lends itself to writing and writing depicts a painting."
<small>CHINESE SAYING</small>

Writing was born of observing nature. Closely bound up with Chinese civilization itself, nature was revered by, and formed the continual point of reference of, the *Wenren*, the cultured individuals of ancient China. Chinese ideograms draw their inspiration from organic forms, such as the tibia that symbolizes the figure one. Words are styled on natural elements.

One of the most beautiful and best-known forms of calligraphy is the cursive hand or "grass-writing." Very free in style, its name in Chinese (*caoshu*) evokes the image of tangled grasses. The calligraphy used in this book follows this style.

Like all Chinese children, I used textbooks containing the basic ideograms printed in red. The learning method consists in using a brush and black ink to color over the red completely in a single gesture, with a minimal amount of correction afterwards.

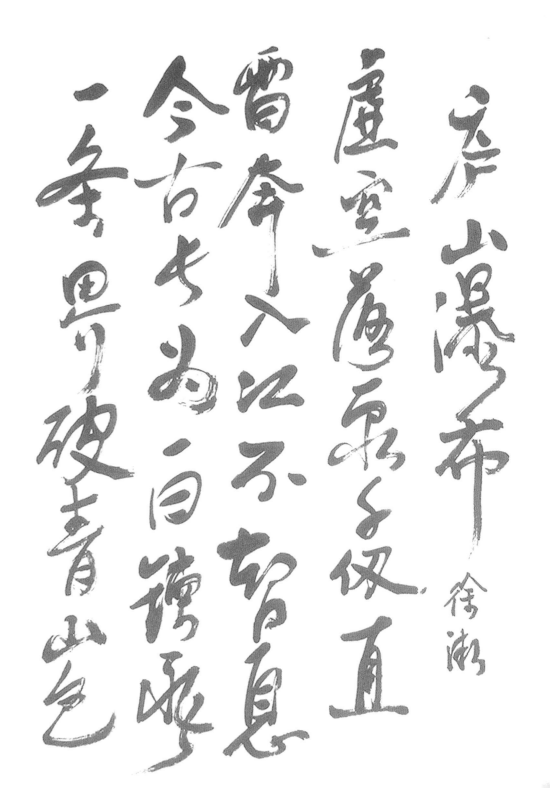

雲南石林

群峰望立

千山五色

森然成林

蔚為大觀

CALLIGRAPHY
Painting in writing

Bamboo is one of the classic subjects in Chinese painting. It symbolizes the intellectual integrity of human beings.

Learning through repetition is central to Chinese culture, as it is through repetition that memory develops. This principle applies to both painting and calligraphy. Calligraphy becomes an art in its own right when it attains a high degree of purity of line and originality of form. The great third-century calligraphy master, Li Su, declared that "the art of calligraphy is delicate and subtle; it achieves harmony with nature through the Tao." According to the masters, the brushstroke should be as swift as the sword or as slow as the toad; it is capable of tracing a line as fine as a silken thread or of making a blotch as heavy as a rock. The brush expresses the spiritual cadence of the person wielding it. Even without being able to read Chinese, it is possible to sense its inherent beauty and to appreciate the spirit and personality of the calligrapher.

Calligraphy is the result of painstaking effort combined with self-fulfillment. When I paint, I try to incorporate the motions of calligraphy into my brushstrokes in order to convey my feelings and emotions, the invisible and impalpable.

YOUNG MUSICIAN

OLD PIPA PLAYER

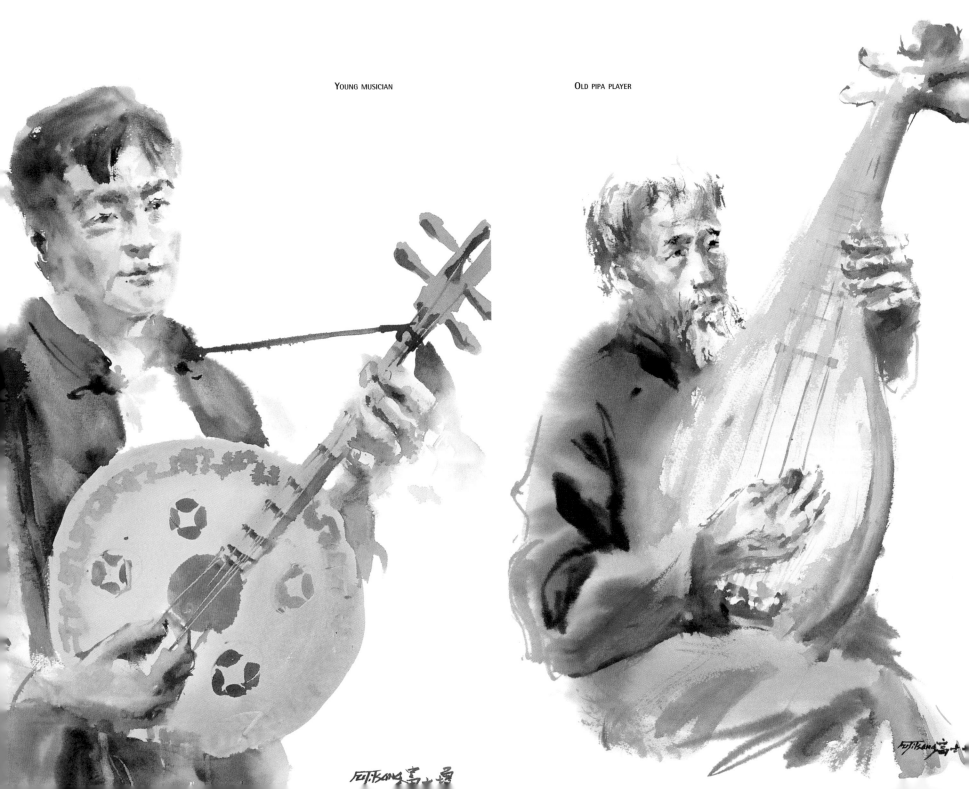

CHINESE MUSIC
A thousand-year history

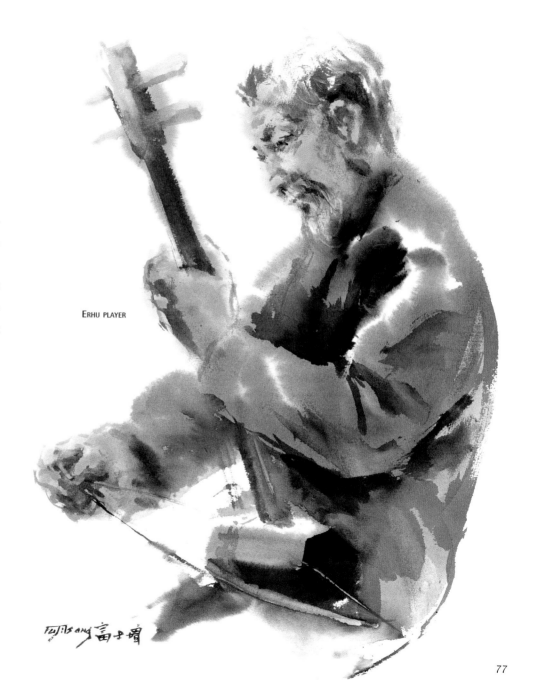

ERHU PLAYER

Chinese music is drawn from a medley of sources. It differs from Western music in its style of melody and its specific musical instruments.

Ritual music dates back to prehistoric times and uses ancient instruments that have now disappeared or are no longer in use. This is the case of a percussion instrument made of hard stone or metal that is rather like a xylophone suspended from ropes, some examples of which are to be found in the Shanghai Museum of Arts and Crafts. The *zheng*, a flat wooden resonance chamber surmounted with strings and the *pipa*, a type of four-stringed mandolin, already featured in the frescoes of Dunhuang dating from the seventh century.

The *erhu*, a two-stringed instrument, and the *dizi* are of Mongol or Weigu origin. The *xun*, with its hauntingly melancholic tones, has been found in sites dating back to the first kingdoms of China. Made of enameled clay, it is similar to the Peruvian ocarina. All of these instruments form part of the Chinese orchestra. As a child, I frequently went to see the Beijing Opera being performed at the local theater or simply

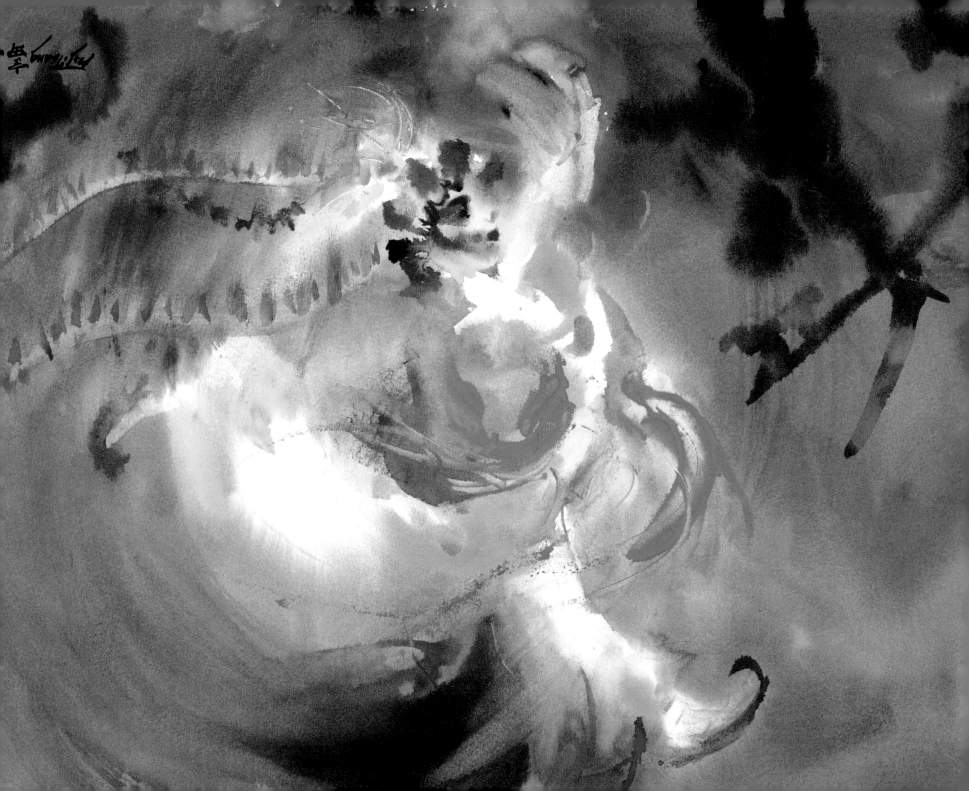

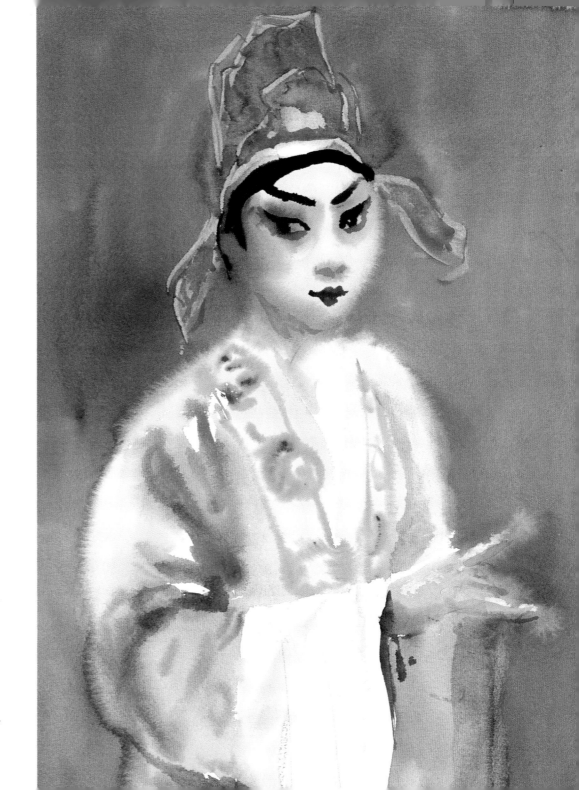

ACROBATIC PIROUETTE IN THE BEIJING OPERA (FACING PAGE)
The combat scenes are very spectacular,
with the actors draped in trailing feathers
and multicolored streamers.

SCHOLARLY CHARACTER FROM THE BEIJING OPERA (RIGHT)
The highly codified colors and designs
of the actors' makeup provide an insight
into the type of character portrayed.

in the open air. The stage is often fairly small and the musicians play next to the singers. During the combat scenes, the acrobatic actors perform pirouettes or somersaults right over the heads of the musicians who, completely impassive, go on playing without batting an eyelid. These operas are very popular. I have often heard workers or laborers singing operatic arias as they go about their jobs! If the performance is held in the open air, people bring wooden benches or chairs and there is always a lot of commotion, with the scraping of chairs and lively chatter. The spectators spit out onto the ground the husks of watermelon or sunflower seeds that they nibble throughout the show. In summer, the dress code is shorts and a T-shirt. Indeed, this is all very far removed from "our" operas, as we know them. Westerners are often taken aback by this atmosphere. I recall one occasion at Datong when the racket was even louder than usual. This was rustic China at its best, with people making comments for all to hear. The foreign tourists finally lost patience with the incessant comings-and-goings of spectators in the auditorium. A group of latecomers—probably officials of

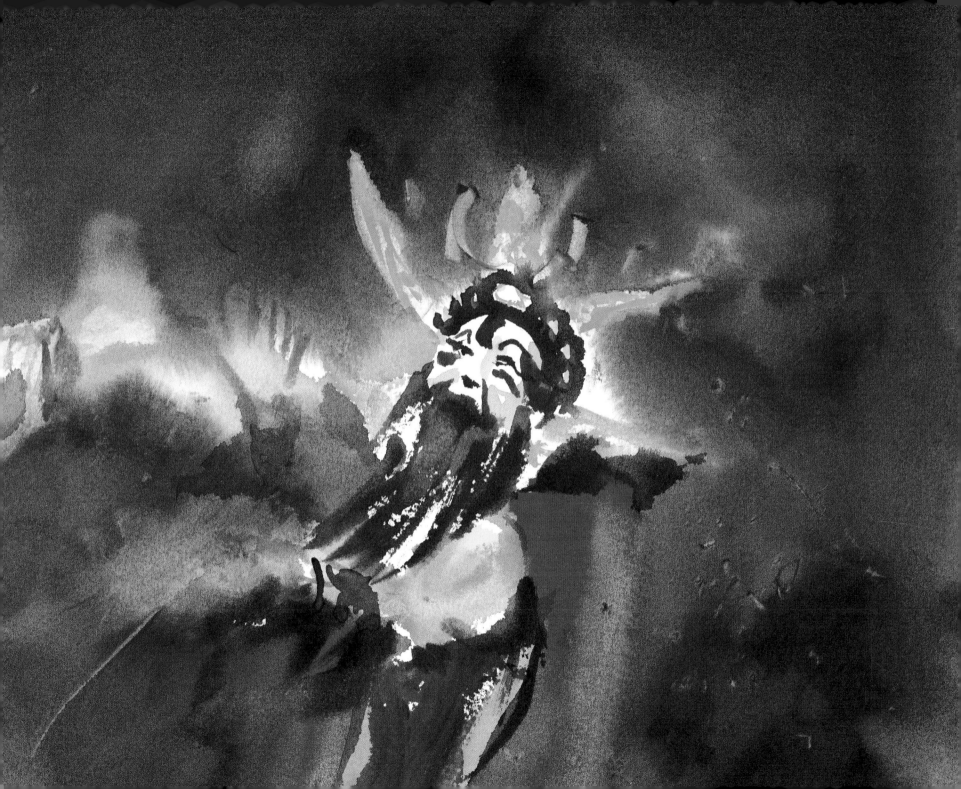

CHINESE MUSIC
A thousand-year history

some sort—had no qualms in settling themselves in the front row, followed by a flurry of waiters bearing tea and sweetmeats. The tourists protested in exasperation. Meanwhile, a local television crew was trying to get a foreign tourist to praise the opera in glowing terms!

Music plays an important role in Chinese marriages. Traditionally, the man goes to fetch his bride at her parents' home, accompanied by musicians playing the *laba*, a kind of horn, and the *luo*, a metal gong. This high-pitched music full of brio conveys the joy of the occasion. When children hear it in the distance, they rush to join the procession to receive a little red envelope containing a few silver coins that are meant to bring happiness and prosperity. This custom still takes place in rural areas; in cities, however, Western-style ceremonies are gaining appeal. In big hotels, weddings are celebrated to the rhythms of Chinese or English popular music, broadcast via loudspeaker systems.

TRADITIONAL CHINESE DANCE
Dazzling diversity

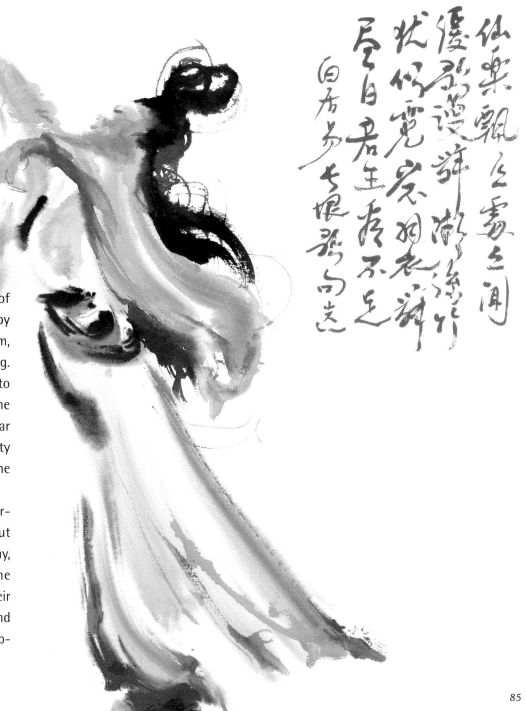

Legend has it that court dances were true feasts of sound and color under both the Tang dynasty, marked by the development of ceramics and the spread of Buddhism, and the Song dynasty, the heyday of poetry and painting. Nowadays, artistic research has enabled performances to reconstruct period décor, music, dance and costumes. The most famous example is that of Xian. The women wear robes with very long, full sleeves that bring out the dignity of their graceful arabesque movements sweeping the space. The men perform staggeringly acrobatic dances.

The "drum dance," popular among the Han, is performed to the beat of this instrument alone, marking out the rhythm for the group. Following a fixed choreography, the men pound large drums that are held upright. The women beat time as they dance, a small drum fixed to their waist. When I was a child, I learned this dance that I found so intoxicating. My whole body would vibrate to the rippling drumbeats.

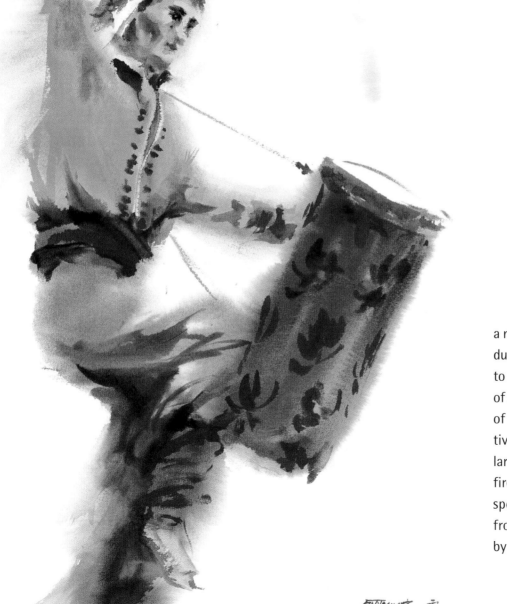

For the minorities of southern China, dance provides a means of communication and meeting people. Each spring, during the Water Festival, the Dai take to the market streets to dance, sing and drench passers-by, perhaps with the idea of sparking a meeting. The Bai gather at Jingpo in the street of the third moon to intone *munao* chants. The Torch Festival, a ritual Yi ceremony, has also become a huge popular fiesta. At nightfall, people of all ages dance around the fire or leap onto the embers, as on Midsummer's Day. The spontaneous nature of the minorities is quite different from the more regimented customs of the Han, codified by Confucian doctrine.

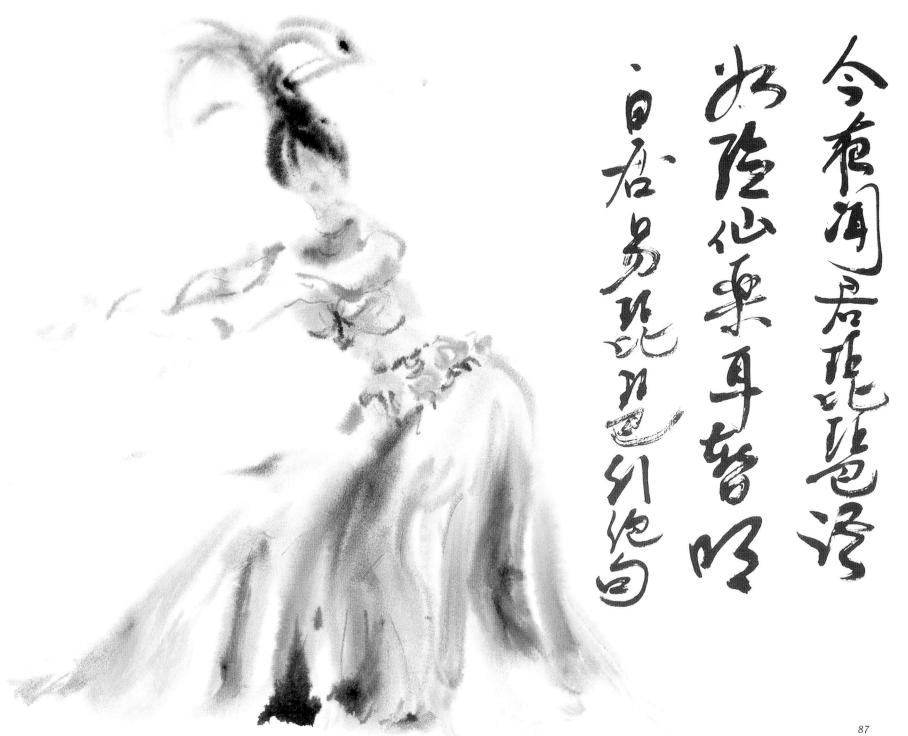

今夜鄜州月
妝陸心東耳暗吗
自君易此此色外他白

PLUM BLOSSOMS, HARBINGERS OF SPRING

TAISHAN

Most sacred of Taoist peaks

Yesterday I saw the plum trees;
New blossoms had already formed.
This morning I heard the spring birds—
And not just two or three chirps!
The ice has thawed, the brook runs free;
The clouds are tunneled, the sky half clear.
My errant heart moves as it should not,
And so I'm hoping for a tryst!

"ON A SPRING DAY VIEWING PLUM BLOSSOMS" EMPEROR CHIEN-WEN
From: Marney, John (tr.). Beyond the Mulberries. An Anthology of Palace-
style Poetry by Emperor Chien-wen of the Liang Dynasty (503–551). Chinese
Materials Center, 1982, p. 163.

According to Chinese mythology, the sky is round and the earth square. As a buttress to the sky made of blue precious stones, the goddess placed five pillars on the earth: one at each of the points of the compass and the fifth in the center. In olden times, the Chinese believed that the sun's birthplace was Taishan, the mountain closest to the East China Sea. Seen from this summit on a clear day, the sea seems as minute and distant as a drop of water in a goblet. Every emperor, from Qin Shi Huang to Mao Tse-tung (the "red emperor"), made the pilgrimage here and had poems inscribed on the cliff face as a sign of veneration. Climbing the steps up this mountain is like taking a step back through Chinese history.

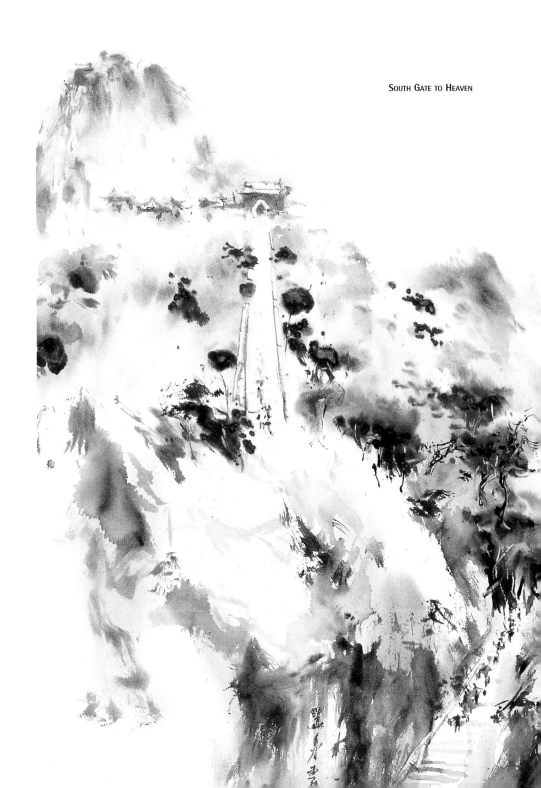

PRAYER (LEFT)

PUSADING TEMPLE
ON ANOTHER SACRED
BUDDHIST PEAK (FACING PAGE)

Standing side by side on this high mountain peak,
We become the boundless, distant landscape,
We become the broad and open plain before us
And the crisscrossing paths upon the plains.

What roads, what waterways are not related?
What wind, what cloud do not echo each other?
The cities, the hills, and the water that we have passed
Are now all within us.

FENG CHIH
From: Lin, Julia C. (intro). Modern Chinese Poetry.
University of Washington Press, 1972, p.147

The Chinese have always revered the mountain, symbolic of the masculine Yang element that molds with water, the feminine Yin element, to attain universal equilibrium.

Of this duality is born unity that in the Tao spirit signifies the Way: the Way of Balance in the face of change and the Way of Life. I love Taishan for its weight of history. Climbing its some six thousand granite steps—sometimes hardly six inches (15 cm) wide—is an act heavy with meaning.

Like most tourists in a hurry, I take the cable car. As it happens to be the last day of its operation before being dismantled, this suddenly makes everyone slightly superstitious. This works wonders for the trade of the hawkers selling little red headbands that sport inscriptions of the place's divine protection. At the summit, there is an imposing gateway known as the "South Gate to Heaven," flanked by the famous stairway of six thousand steps. The crowd, as closely packed as an army of ants, takes this path of hewn stone set down by stonemasons in the middle of nowhere. Four men are needed to carry one of these stones that must weigh

over 220 pounds (100 kg). Their shirts are drenched with sweat and their bodies marked by the sun. Gazing fixedly, they ascend at a slow, regular pace to save their strength.

I reel at the thought that there are tens of thousands of these steps covering every side of the mountain. Going up or down these thousands of steps is not without difficulty or muscular pain. But legend has it that whoever climbs Taishan will live to be a hundred years! Every so often there is a welcoming platform that invites one to contemplate the landscape or the inscriptions etched into the rocks. Those written by the emperors of the Song and Qing dynasties pay homage to the Taoist deity who grants peace to the kingdom and harmony to the seasons. At the Middle Gate to Heaven, I raise my eyes above the treetops. In the distance, the stone path linking this gate to the Gate of Heaven shimmers in the sun like a white ribbon on a mountain of jade.

On the wind-beaten plateau at the summit, the Azure Clouds Temple receives the offerings of pilgrims. Taoist monks, who are masters of astrology and alchemy, interpret enigmatic poems inscribed on small sticks that visitors draw at random after making a wish. I go up to them. Such is my surprise when I see that they are unable to read the texts,

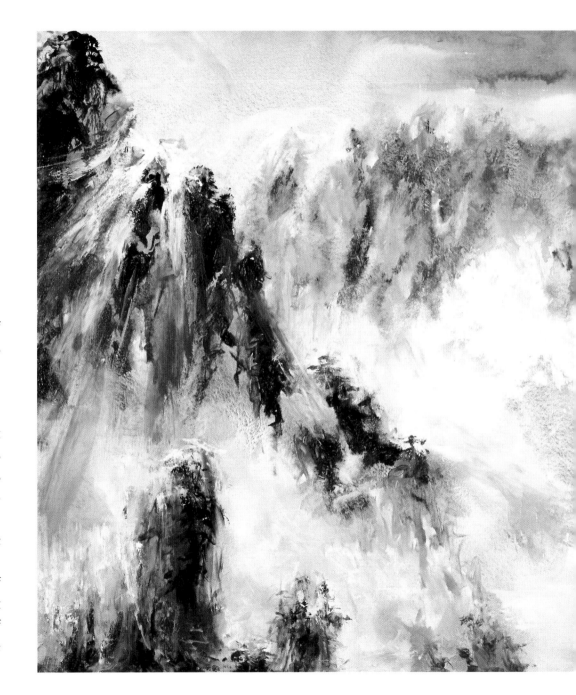

let alone interpret them! I feel a sense of shame when I realize that this sanctuary, a sacred hub of Taoism where rites have been practiced for thousands of years, is now peopled with little more than peasants in disguise. So just where are these great Taoist or Buddhist monks who pass on philosophical principles and rites? Surely this scene is a caricature of present-day Chinese society, which preserves its traditions in appearance only! While China has certainly made much progress in terms of economics, it still has a long way to go before it can recover its cultural and spiritual wealth.

For the Chinese, the mountain stands as a melting pot of the elements. When mountain meets water, this evokes nature in all its fullness. Landscape painting is known as *shansui* (literally, "mountain and water painting"). These two elements come together at Taishan in the form of a thundering cascade or an emerald river surrounded by majestic pines. They are sometimes enhanced by a stele, a pavilion or a temple. Whenever I paint a mountain, I am aware of this balance of Yin and Yang. Empty and full. Without emptiness, fullness is little more than an accumulation of signs devoid of any poetry. Without fullness and its sense of the concrete, emptiness holds no meaning.

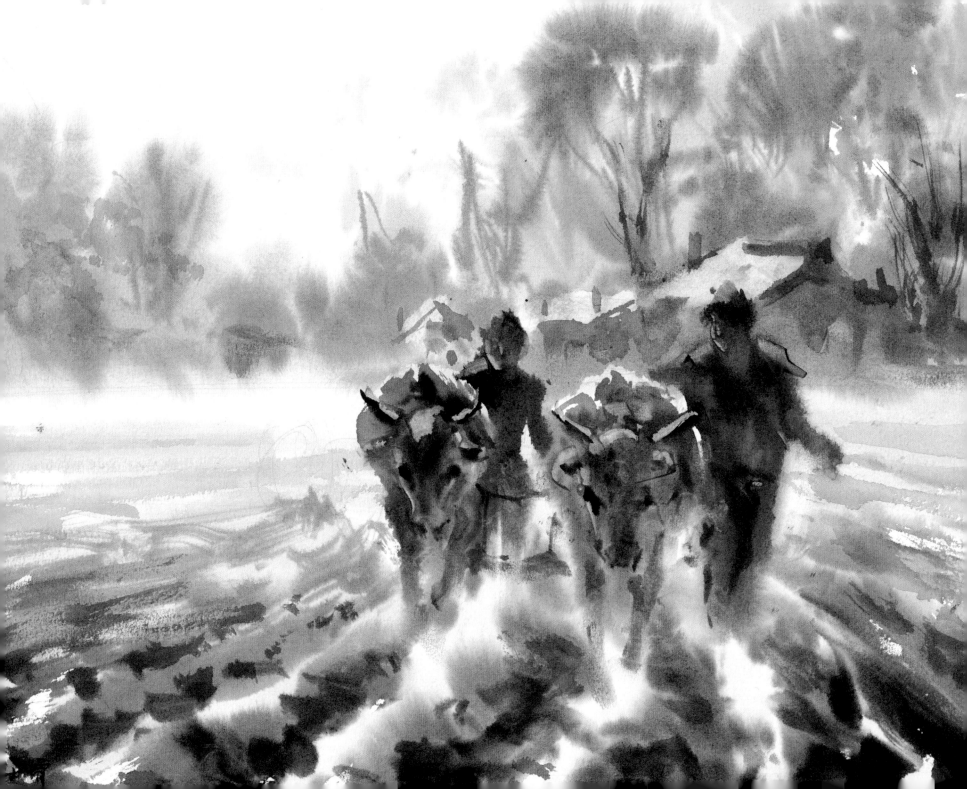

XIAN
Birthplace of Chinese civilization

MONGOL BARBECUE

The Loess Plateau surrounds the basin of the Yellow River in Shanxi Province, whose capital was Xian during thirteen different dynasties. The most famous of these is the "Qin." It was here that Chinese civilization was born. Legend has it that Huang (meaning "yellow" in Chinese), one of the first mythical emperors, is the father of all Chinese, who have since regarded themselves as the "yellow" sons. In 221 B.C.E., the Prince of Qin, one of the seven Chinese kingdoms, succeeded in forcing out his rivals and uniting China for the first time. He established a single currency, a common system of measurements and writing for the whole of China, and ordered the construction of the first Great Wall, a section spanning some 3728 miles (6000km). The megalomaniac Emperor Qin Shi Huang was no ordinary man; he sought to found an empire that would endure for "Ten Thousand Generations." According to custom, during his lifetime the emperor had a monumental tomb built. It was here that he would be buried with his treasure, as well as an army of guards to protect him in the next world. With its famous Terracotta Warriors, Emperor Qin Shi Huang's

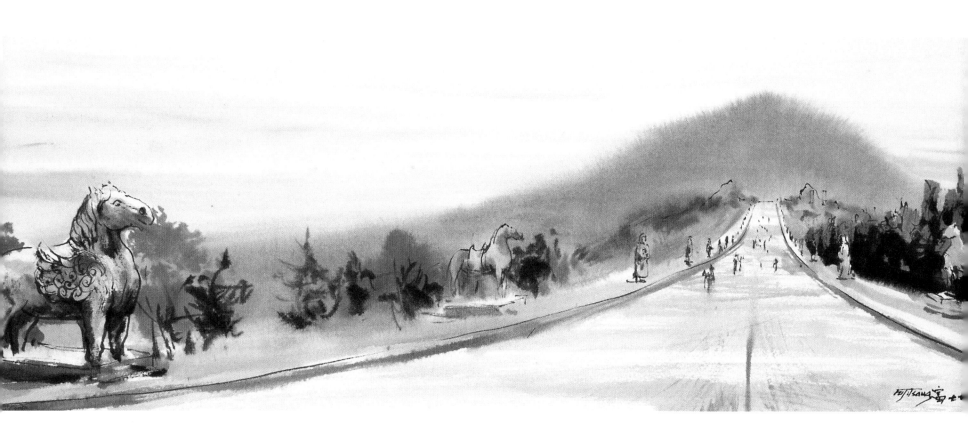

tomb was the most imposing mausoleum ever. The Terra-cotta Army is made up of horses and over six thousand soldiers, measuring between five feet nine inches (1.80 m) and six feet four inches (1.96 m) in height according to their rank. I have visited this huge pit—as big as several football pitches—on several occasions. The statues remained buried for over two thousand years. The firing method used in their construction, as well as the relatively dry climate, account for their fine state of preservation. These warriors were originally painted with bright colors that have oxidized over time. Some still bear traces of this yellow clay. Only the front rows of soldiers have been completely restored,

MONUMENTAL STAIRCASE LEADING TO THE SACRED WAY
The size of this staircase gives us some idea of the Empress's authority. It should come as no surprise that Mao's wife styled herself on her.

and each facial expression is different. I am gripped by strong emotion every time I come here—what a wonderful piece of work it is!

The Qianling Tomb, belonging to Wu Zetian—the first empress to have ruled the country—is quite different from that of Qin Shi Huang. Despite the nine hundred years separating these two figures, they share many of the same character traits. A concubine to Emperor Taizong of the Tang dynasty, Wu Zetian managed to seduce his son. When his turn came to ascend to the throne, he made her his empress. Wu Zetian took to assisting her husband in affairs of State. When the emperor died, she progressively seized power,

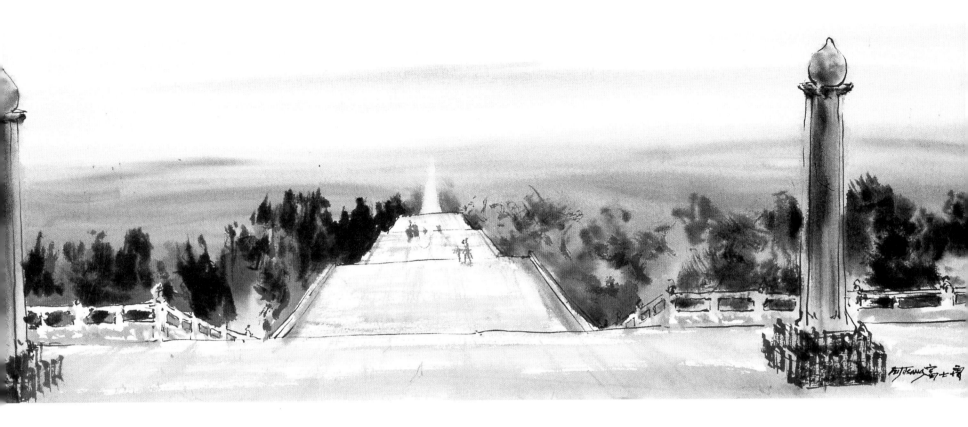

established herself on the throne and founded a new dynasty. Breaking with the tradition of burial mounds constructed on a plain, she tastefully selected an imposing verdant mountain on which to set her own tomb. A river winds its way through the valley. The ascent begins with a straight road, followed by a monumental staircase of several hundred steps leading to the Sacred Way that runs for 1640 feet (500 m) along a ridge. Two winged horses, inspired by legends from afar, stand guard at the entrance. There are statues of mandarins, generals, ambassadors and animals—mythical beasts along with creatures such as elephants and ostriches not indigenous to China. At the far end of the avenue, two huge

THE SACRED WAY OF QIANLING, TOMB OF EMPRESS WU ZETIAN
From the top of this staircase, the avenue, lined with statues, stretches as far as the eye can see. It is hard to do justice to the vastness of the site, even from such panoramic views.

lions made of marble protect the sanctuary. In accordance with custom, a turtle—the symbol of longevity—carries on its back two steles measuring twenty feet (6 m) in height. The first is inscribed with a text glorifying the emperor; the second has been left blank. Does this imply that there are no words to describe the work achieved by the empress, or perhaps that she preferred to leave history to define her controversial life? It doesn't really matter. Wu Zetian was an exceptional ruler. In a country heavily impregnated with Confucian doctrine where the woman's place is in the home, she was the first woman to enjoy an equal footing with her male counterparts.

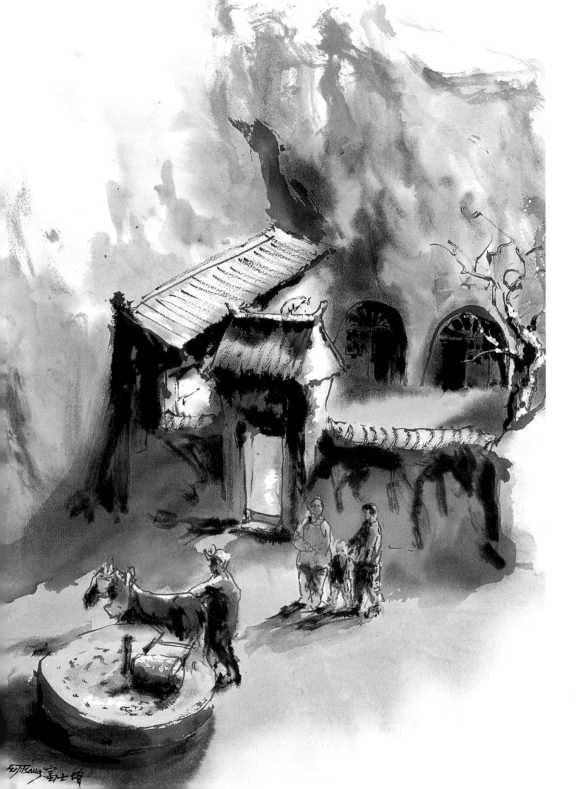

GATEWAY AT THE ENTRANCE TO QUFU, BIRTHPLACE OF CONFUCIUS (FACING PAGE)
Born 2,600 years ago, Confucius advocated humanism and wisdom by the Middle Way. Located far from the main roads, Qufu is a haven of peace and serenity.

As well as being home to thirteen dynasties, Xian was also one of the most important sites in the spread of Buddhism from India. During the Tang era, the emperor dispatched a monk to Nepal to look for sacred writings. After a highly eventful journey, he returned with the sutras, texts that bring together a set of rules for rites, ethics and daily life in the form of short aphorisms. One of the four classic Chinese novels, *Pilgrimage to the West*, gives a phantasmagorical, legend-filled account of this monk's adventures. When I was a child, I loved to listen to old people recounting these fantastic episodes in which evil spirits and wicked demons vied with each other to find the most ingenious way of preventing the monk from completing his pilgrimage. One of the most famous chapters tells of the Monkey King with his magical powers and indomitable character. These stories are so popular that they are to be found in the Chinese Opera and on the frescoes that adorn the covered walkways along the lake of the Summer Palace in Beijing. The Big Wild Goose Pagoda was erected in homage to this monk. There is also a Little Wild Goose Pagoda, built amidst

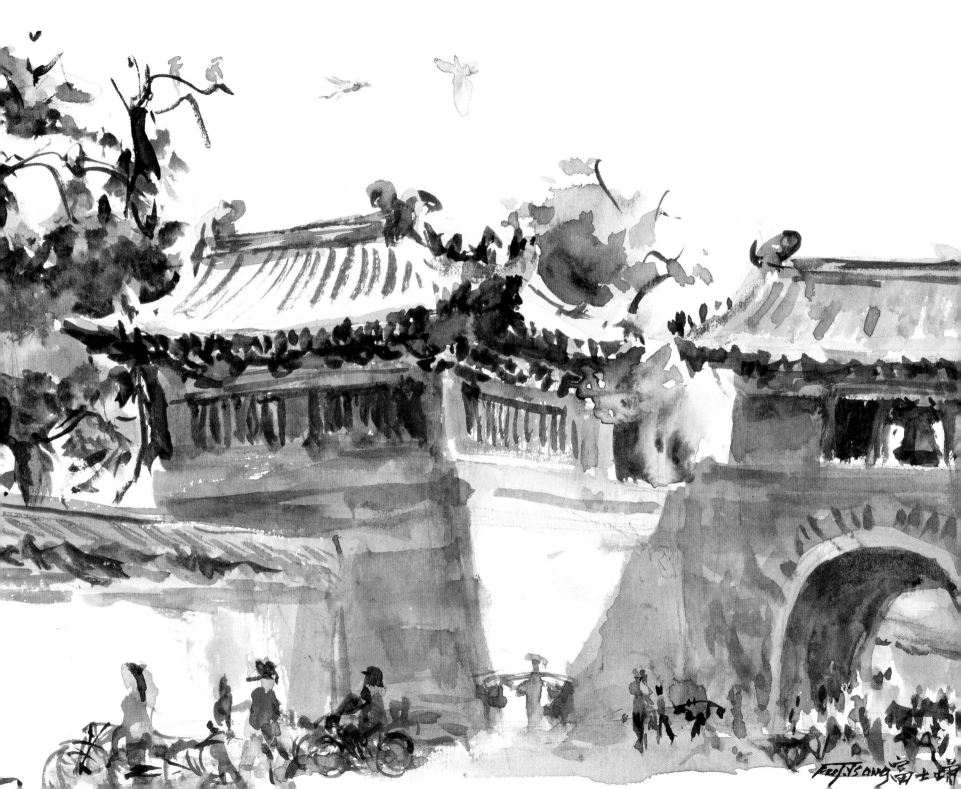

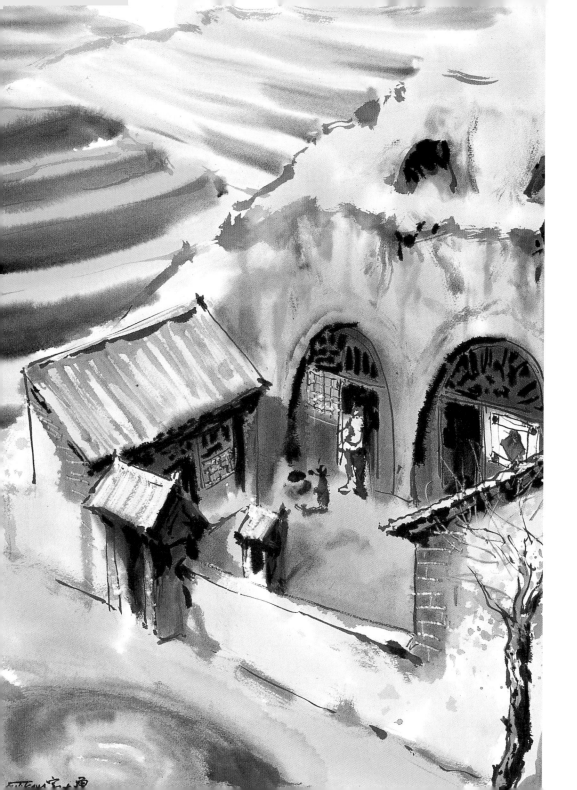

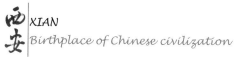

XIAN
Birthplace of Chinese civilization

LOESS PLATEAU

a verdant park of great charm, where many artists come to study traditional Chinese painting.

Xian was not only a leading site in the spread of Buddhism, it was also influenced by Islam. A crossroads of trading routes between China, Central Asia and Persia, it marks the start of the Silk Road. One of the legacies of this intermingling is the presence of a large Muslim community. Indeed, one of the greatest mosques, built like a temple, is to be found in the very heart of Xian. Mutton-based Moslem cuisine is also very popular, and may be sampled "At Jiasan's" where I came across one of the best steamed buns I have ever tasted. They could not be any juicier! The secret would seem to lie in injecting the bun with broth that has been nicely simmered. Another of the region's specialties is the dumpling that comes in a wide range of shapes and forms with a variety of fillings. The taste and style of preparation are quite different from those in Europe, but I find both equally delicious!

There is an element of originality in both the customs and the food of this region. While the local cuisine lacks the

Three rooms carved into the cliff face, their façades
partially covered by corn and chili twisted into long braids,
with one wing for the cowshed, a yard partly used
as a vegetable garden, and the area in front
of the house that serves as a threshing floor during
the harvest season: such is the backdrop to rural life
on the Loess Plateau.

variety and refinement of Cantonese cooking, it remains
highly flavorful. One typical dish consists only of garlic and
chili peppers. Far from the coastal areas, people here have
retained their customs.

The high Loess Plateau stretches for thousands of
miles in the Xian region. Life there is quite different from
that in the big Chinese cities. Rather, it is the reflection of
age-old China. It just so happened that I was traveling in
the region after a landslide. My driver, a kind young man,
decided to make a detour and took a different route from
usual. We found ourselves on a long road full of potholes
that every so often crossed a quiet village. We saw children
going to school on foot. There was so little traffic that they
could walk and play in the street. If it weren't for the fact
that they went to school, the lives of these children would
be no different from those of their ancestors, punctuated
by the seasons and labor in the fields.

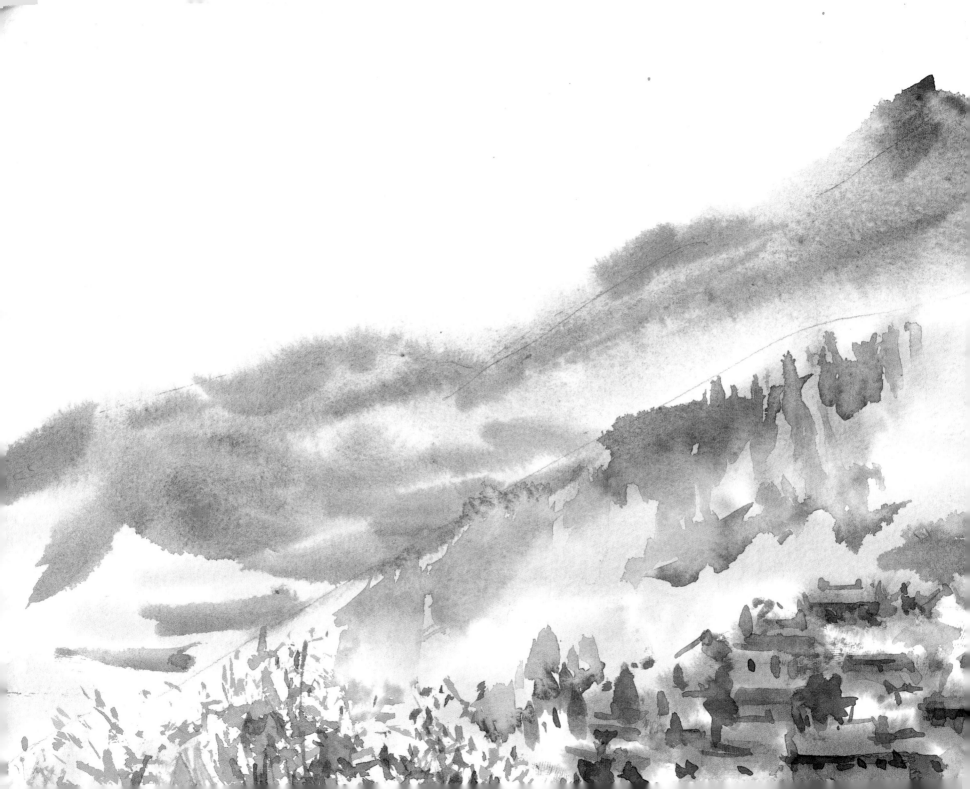

FROM XIAN TO DATONG

*An ideal route for discovering
the Loess Plateau and its treasures*

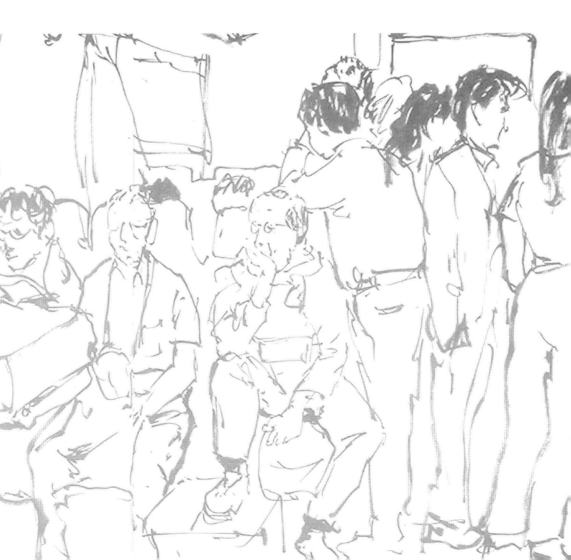

The route linking Xian to Datong crosses the basin of the Yellow River. Train travel in China is a unique experience. The Chinese railway is rather quaint with its first class called "soft seat" as opposed to its "hard-seat" second class, where passengers are jammed into non air-conditioned carriages. I was once in a crowded train with a group of French friends. Unluckily, our seats were already taken. We managed to squeeze our way in amongst the other Chinese passengers as best we could, our baggage on our laps. Railway employees regularly passed through the carriages selling tea, food or small trinkets, forcing their way through with difficulty. The carriage was rank with the smell of sweat and cigarettes! Yet no one lost his or her cool. A three-hour journey in such conditions makes you wish you had taken first class—even if you enjoy rubbing shoulders with the locals!

Pingyao, listed by UNESCO as a world heritage site, is a fortified city. Eight entrance towers are set on the high ramparts surrounding it. Just inside the old city, crowds of mainly Chinese visitors throng the "antique" shops and restaurants serving local specialties. The houses lining the main streets

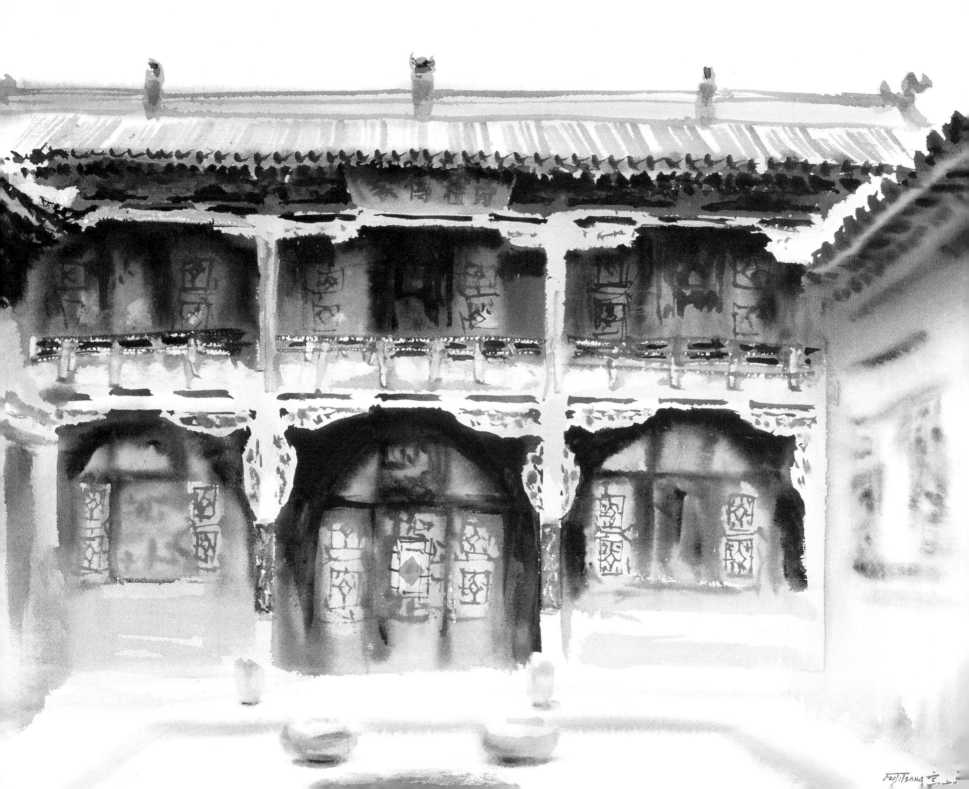

FROM XIAN TO DATONG
*An ideal route for discovering
the Loess Plateau and its treasures*

PINGYAO PAINTER'S HOUSE (FACING PAGE)

are typical of northern Chinese architecture. Away from the shopping streets, the house of a famous painter of the Qing dynasty is tucked away in a residential area. A small yard, formerly used as a place for supplies, separates the unassuming entrance from the main courtyard, with its two rows of houses to the east and west that set off the main south-facing mansion. Behind this main house, there is a series of courtyards, probably for the descendants. A stone staircase takes me to the second story where three rooms open onto a balcony with a panoramic view over the gray roofs of the old city. The studio is bright and ideal for a painter looking to cut himself off from the world. The columns, beams and windows are made of lacquered wood, whose varnish has chipped with the passage of time. The walls of light gray brick and the dark gray tiles of baked clay, as well as the finely-sculpted rooftop cornices and chimneys, lend an air of sober elegance to the whole. It is no less beautiful for the marks of time. I feel lucky to have been in this authentic place before it is transfigured.

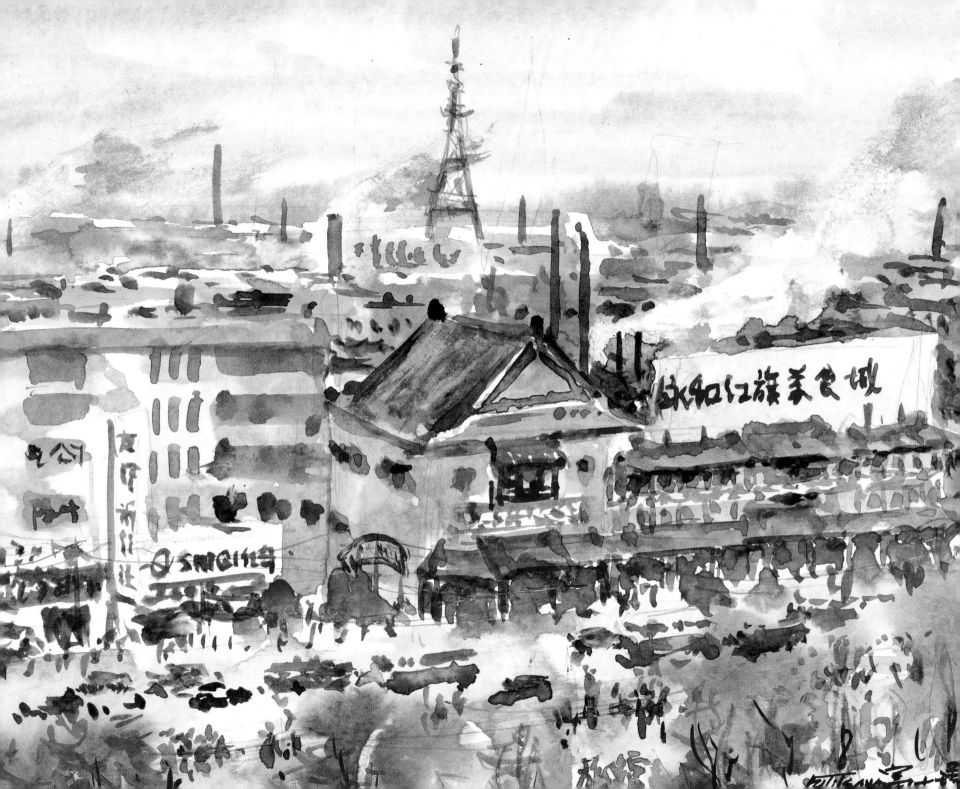

THE DATONG REGION
Quintessence of art and faith

DATONG, CITY OF COAL (FACING PAGE)

SHANXI PEASANT (RIGHT)

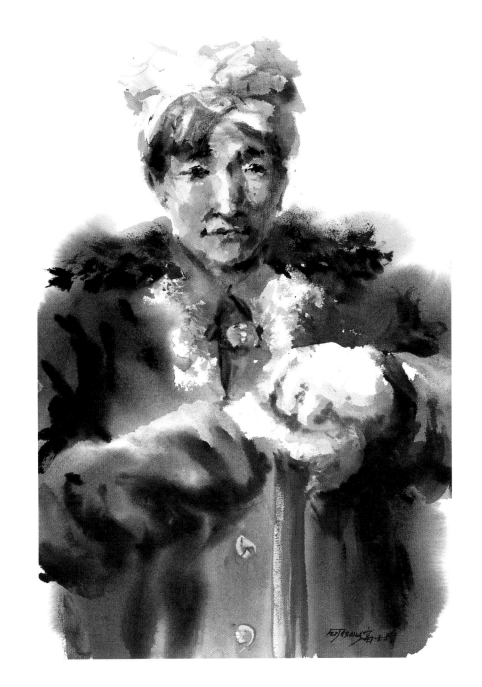

Wild and beautiful, the Datong region is like the men of the North—hale and hearty. Its deep gorges, its prominently-crested peaks, and its basins gouged out by erosion make for an impressive, mysterious atmosphere in the ever-changing light. To the east and north, the Loess Plateau stretches away endlessly into the distance. This yellow earth was carried here long ago by the Siberian wind. Cultivated terraced fields surround the summits hewn with deep ravines. Troglodyte dwellings hollowed into the cliff-face punctuate nature. All farming is done manually by peasants, who use donkeys to transport their wares on the steep trails.

To the west, the small town of Yingxian is like a little jewel set amidst a fertile plain. Here, the largest wooden pagoda in China rises majestically to a height of 220 feet (67 m). I was surprised by the steep staircases and the low beams during my ascent. At each story, a pair of painted wooden statues of Buddhist divinities greeted me in a solemn silence, broken only by the sound of the creaking floorboards beneath my feet. Pillars leaning inwards towards the center in an

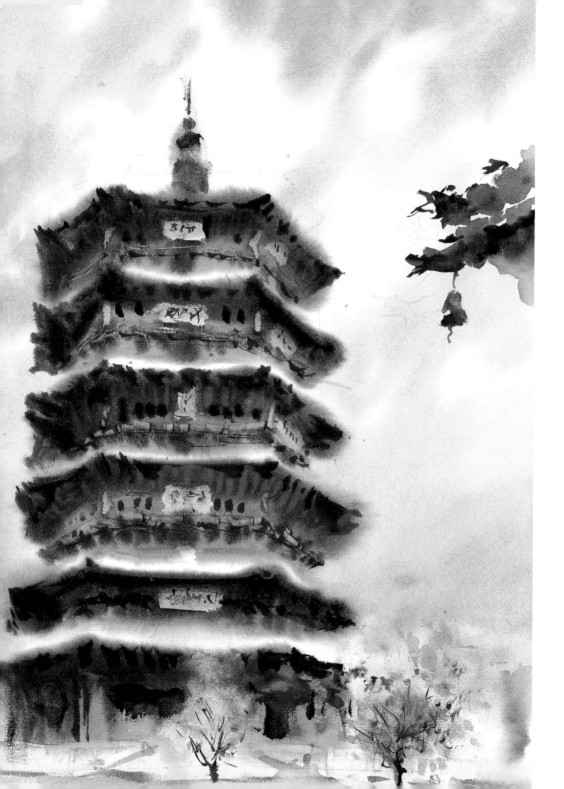

intricate weft of beams and small pieces of wood lend stability to the whole structure, as per the sophisticated technique of mortise and tenon joints found in most buildings in China. The pagoda has remained steadfast for 1,200 years, withstanding earthquakes and any number of trials. Fire alone presents any real threat to destroy it—this is indeed the reason for the disappearance of most of the historical buildings of ancient China.

To the south, Hengshan—one of the four sacred mountains—has an abundance of interesting sites. At the turn of one bend, a cliff towering for hundreds of feet overhangs a steep-sided valley. Halfway up, a hanging temple with a series of covered walkways and pavilions clings perilously to its side. Tree trunks seem to have trouble in supporting the structure. How much longer will they withstand the strain? This apparent fragility is, however, only an illusion. In reality, crossbeams are wedged deeply into the cliff, providing the structure's foundations. Over a thousand years ago, builders would recklessly descend the length of the crag on the end of ropes in order to construct this hanging temple. In the fine drizzle,

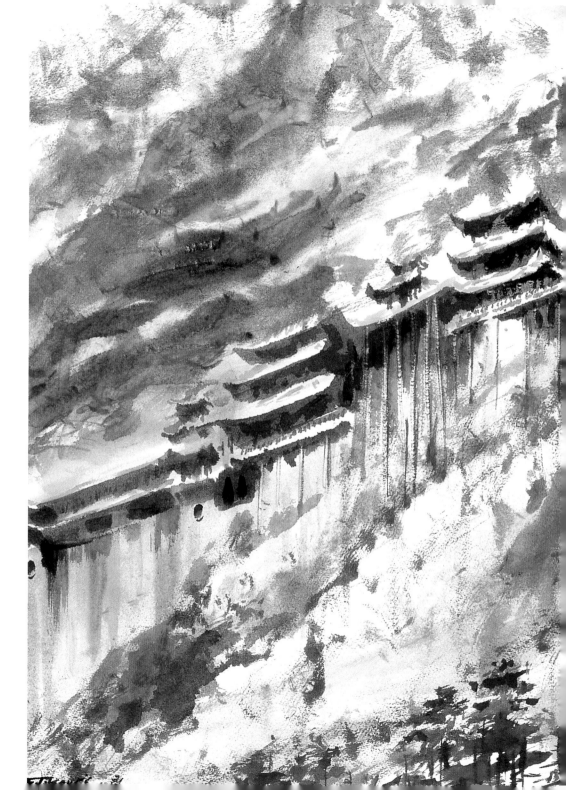

walking on these narrow footbridges so near to the void is like strolling on a path of clouds!

The caves at Datong with their frescoes and Buddhist statues carved into the rock on the mountainsides are equally as stunning as those at Dunhuang on the Silk Road. Their age and size make them remarkable: one of the statues dates from the fifth century. They possess a wealth of architectural detail and an audacity in their execution worthy of that of a cathedral.

These "cathedral caves" are monumental structures— a fusion of art and faith. In the early days of Buddhism, teachings were delivered orally, and there were no statues or temples. India learned these major arts when it came into contact with ancient Greece via Alexander the Great's expedition to Central Asia. From the sixth century, the Persian influence was apparent in the use of arabesques and geometrical patterns. Through the Silk Road, the Chinese incorporated these different forms of art into the construction of their "cathedral caves." The builders hollowed out a large cavity towards the summit of the hill. They sculpted the head

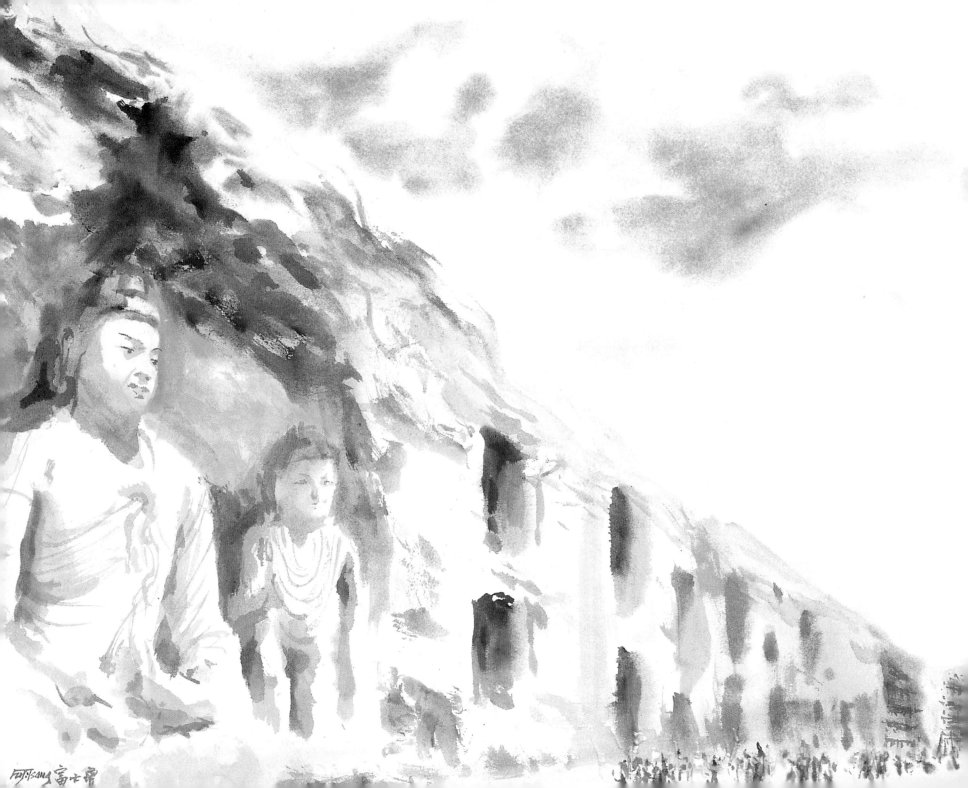

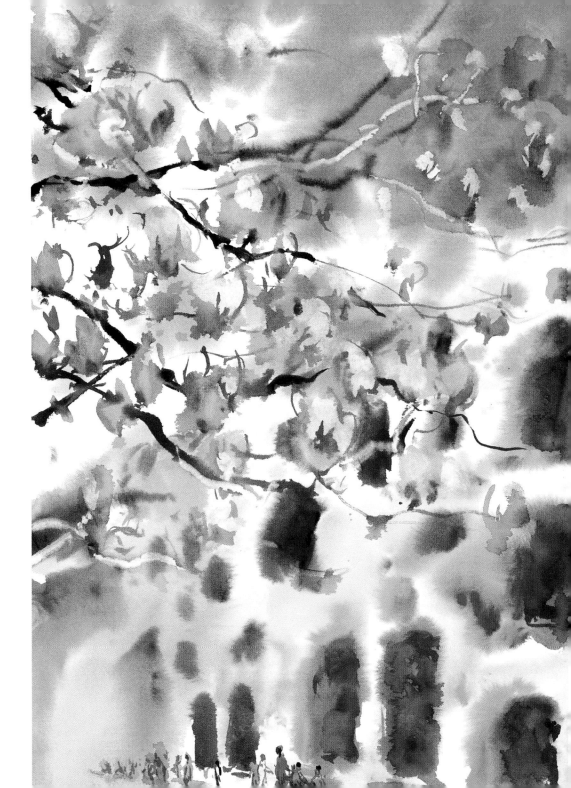

YUNGANG CAVES IN SPRING
Faith can move mountains.
Here, it digs into the mountain
to make it sacred. At Yungang,
various forms of art—sculpture,
painting, architecture—come together
to make one of the oldest and most
complex sites in China.

of Buddha, which was to fill the upper portion of the cave. They then enlarged the inside by continuing the sculpture from top to bottom, finishing with the opening of the main entrance at the foot of the hill. This technique meant that work progressed swiftly and dispensed with the need for scaffolding. The design and step-by-step creation of such a gigantic work certainly required an overall vision, an estimation of the proportions, and exceptional imagination. Inside Cave Number Six, I admire a ceiling richly decorated with bas-reliefs and paintings. In the center Buddhas sit enthroned, their expressions mild and benevolent. During the Wei dynasty, some devout emperors even raised Buddhism to the ranks of State religion—an event unique in the history of China. They apparently hoped to win immortality in the form of Buddha. Were they seeking to gain the veneration of generation after generation of pilgrims? Or did they wish to hold both political and spiritual power? It is extraordinary to think that this colossal achievement was the work of a northern people who would rule China for only a hundred years!

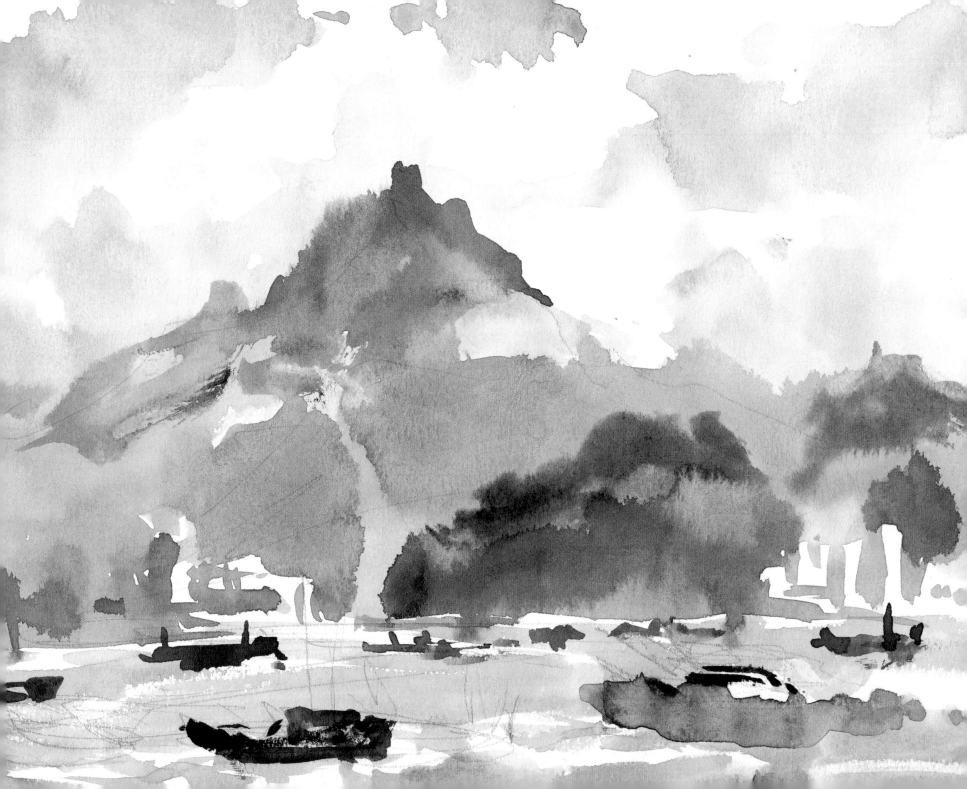

CANTON AND HONG KONG
Pearls of modern China

MOUTH OF THE PEARL RIVER, NEAR HONG KONG

Located at the mouth of the Pearl River, Canton—Guangzhou in Chinese—is the largest city of the south. In the seventh century, European merchants and sailors landed there with the aim of colonizing China. They imported opium from their trading posts in the Indies in order to weaken the country's defenses. By way of retaliation, the high commissioner of the province, Lin Tse-Hsu, had the opium stores burned down, which led the English to trigger armed conflict. The British fleet launched a surprise attack on the Chinese imperial army. They demanded a huge amount of compensation from the Qing Court and the annexation of the island of Hong Kong. Thus began the extraordinary history of this tiny territory that my family was to make its home.

My grandparents on my mother's side were of Hakka origin. This northern people, whose name denotes "guest," decided to flee their land in order to escape from barbarian invasion. They were to seek refuge in the Maiqian district in the far south of China. Their dialect, customs and dress were markedly different from those of this region.

They would often wear dark clothes and a bamboo hat trimmed with black fabric.

I will never forget my first trip to Canton in 1966. From Beijing, it took two whole days and nights to get there by steam train. Police stood guard outside the only hotel reserved for "foreigners" and made us wait for a long time before we were allowed to enter. A few "long noses" and overseas Chinese were wandering around the lobby; their colorful clothes marked them out from locals who were forced to wear green or blue. In the hotel restaurant that was so empty you could have heard a pin—or rather a chopstick—drop, I took great delight in discovering Cantonese cuisine and its *dim sum*, these varieties of small steamed dumplings. A real feast replaced our usual dearth of food. The museums appeared all the more dusty and deserted in contrast to the streets, which were enlivened by Red Guard parades. Shortly after our trip, historical and cultural treasures—which the demagogues deemed the "Four Olds"—were destroyed.

I was to see this region again later when we made a clean break with China for Hong Kong. Most passengers

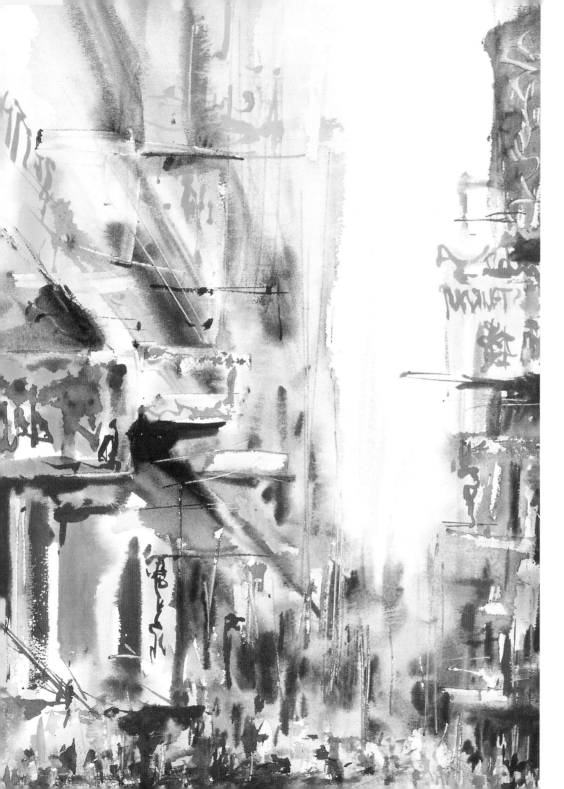

got off at Canton station; those remaining "turncoat" families, looking to continue through to the border, were scrupulously checked by the military police. An hour after leaving Canton, the train crossed a lush landscape of rice paddies and tropical forests. In the carriages the heat was stifling and the atmosphere leaden. Everyone knew that the army and militia plied this area that borders onto Hong Kong where a special residence permit was required. The slightest hitch would have put an end to our quest for freedom, and we were petrified with fear as we made our way across Shengzhen, the small border town of no particular charm. Nepalese soldiers of the Foreign Legion and the police greeted us in English or Cantonese only. It was quite a different universe! Once we had gone through the formalities, we were given a provisional identity card protected by a plastic film. This would replace our Chinese pass, which was simply a piece of paper. This was the first time that I had held an official document!

A second train took us to Kowloon, the tip of the colony's mainland peninsula. We watched as all manner of

CANTON AND HONG KONG
Pearls of modern China

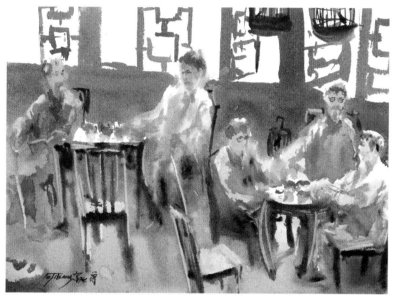

high-rise buildings, industrial parks and shipyards flashed by. Taxis, minibuses and English double-decker buses drove around in an unbroken, orderly line. Crowds of people walked along at a brisk pace. Hong Kong seemed like a hive of activity. We marveled at the array of buildings and the abundance. Everything seemed so beautiful and so easy! But we would come down to earth very quickly. In our little room, our future seemed quite bleak. The two thousand *yuan* that we had been allowed by China to bring with us would last for little more than a week. Each member of the family immediately set about looking for work.

I also like to paint the small streets that link Victoria Peak to the districts of Central and West Point. Steep and narrow, they are lined with workshops belonging to a variety of small trades: engravers, secondhand booksellers, dealers in secondhand goods and designer seconds. Right beside them are smoked-glass buildings that house the headquarters of some of the most powerful multinational firms and banks in the world. The contrast could not be more striking! When the offices close, a human tide surges in an orderly manner into the streets; without such discipline, Hong Kong would be verging on collective suffocation.

Ever since I moved to France, I have made regular trips back to Hong Kong to visit my family and exhibit my paintings. I am always struck by the briskness of the population and the dynamic nature of this cosmopolitan society. The place is fascinating in its diversity and extravagance. In the evening on the Tsimshatsui or Hong Kong seafront, it is hard not to fall in love with these scenes, found nowhere else in the world: lights of myriad hues from thousands of illuminated high-rise buildings are reflected in the clouds and water, visible for miles around.

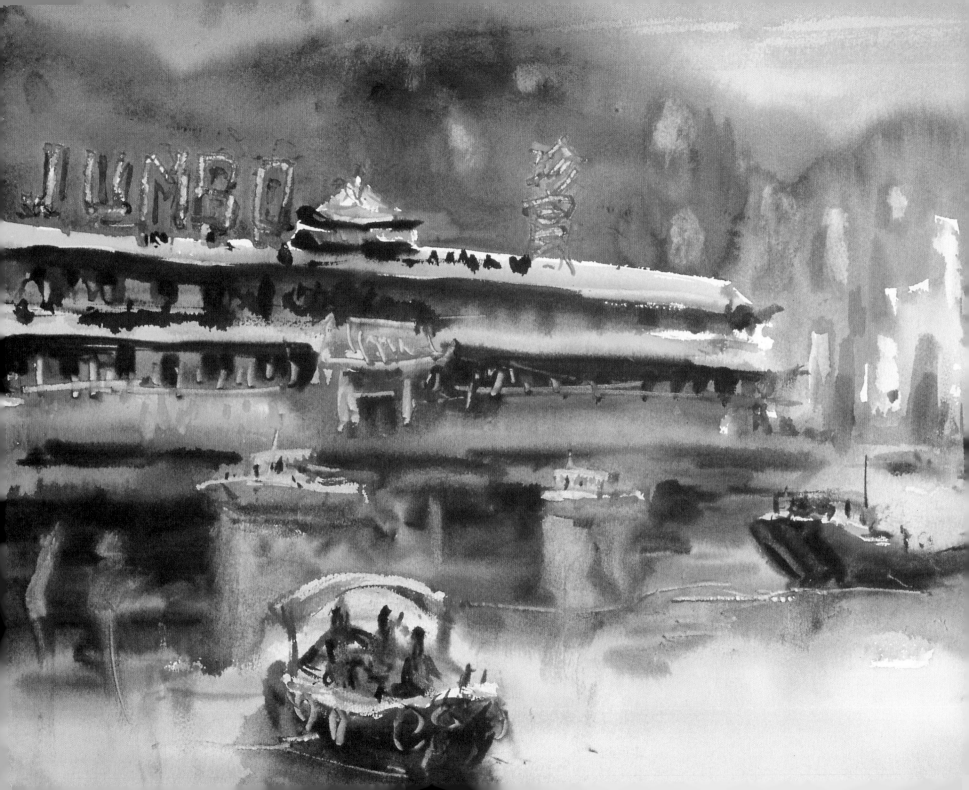

Port of Aberdeen, Hong Kong (facing page)

Garden of the Chen Family Shrine
in Canton (right)

When I visited Canton province for the third time in 1993, I was stunned by the way it had changed. In the space of eight years, the creation of the Special Economic Zone (SEZ) on Deng Xiaoping's initiative had turned Shengzhen into a major city with several million inhabitants. Brand-new skyscrapers had shot up like mushrooms. It is disturbing to think that such conurbations have spread throughout Guangdong Province, replacing traditional villages and typical districts. The rice paddies and forests have given way to soulless urban landscapes.

Imbued with southern Chinese tradition, the Chen Family Shrine is a place of meditation. Confucius taught that we should respect our ancestors. Their experience and charity bring peace and prosperity. Success is credited to parents and, by extension, to former generations giving rise to ancestral worship, which foreigners may find inordinate. No expense is spared to honor this place: the delicately sculpted panel of precious wood that adorns the entrance wall; the marble-encrusted furniture in the reading room; the brickwork bas-reliefs depicting historical scenes; or the roofs surmounted with polychromatic sculptures.

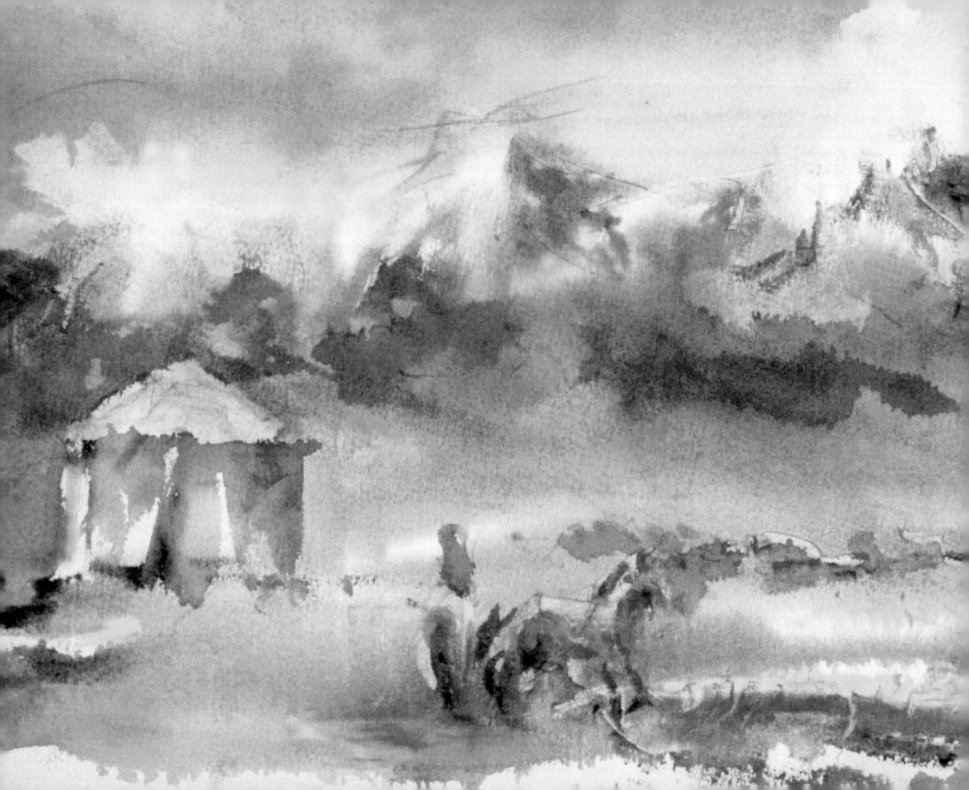

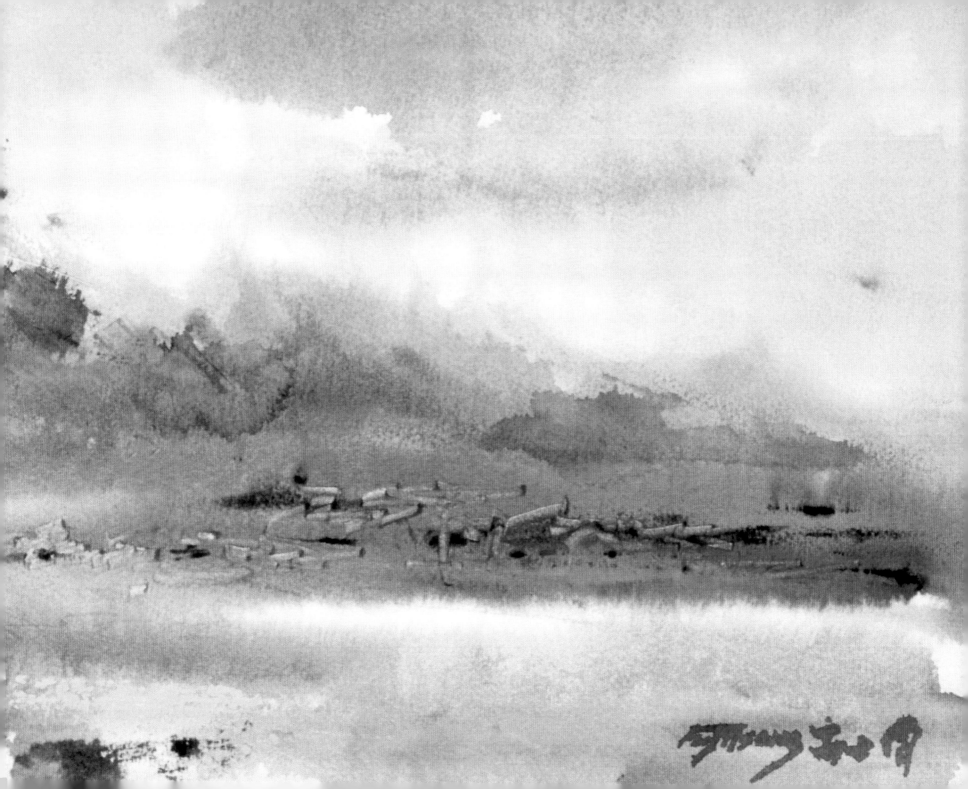

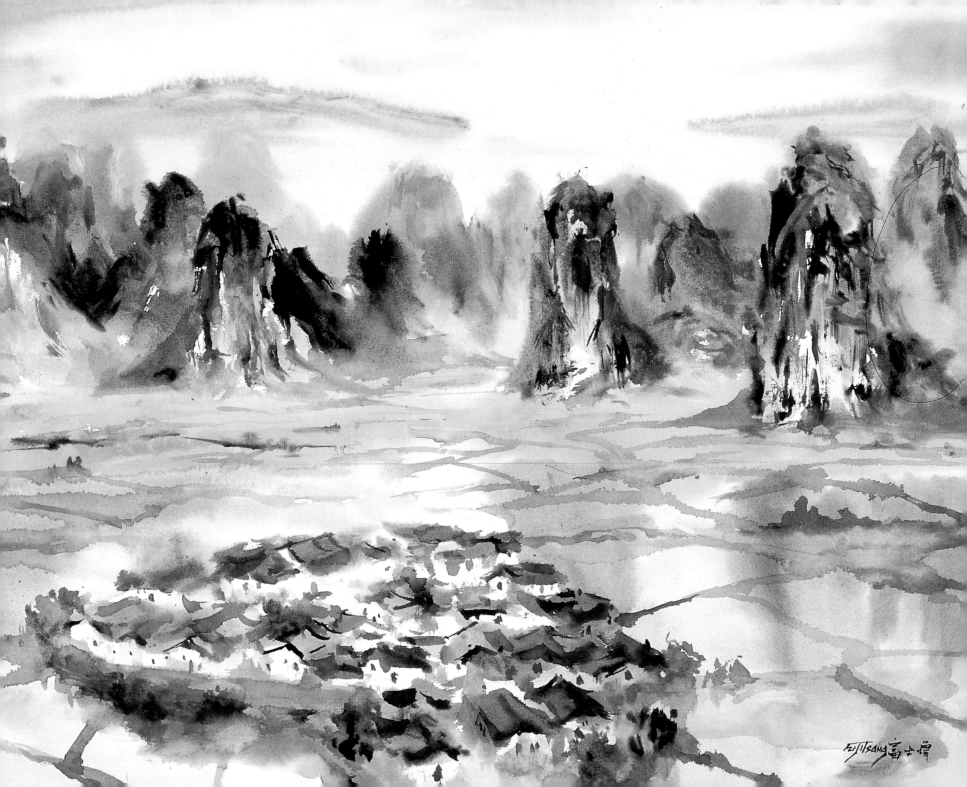

GUILIN AND YANGSHUO

桂林

Harmonious union of mountain and water

桂林山水甲天下

I first discovered Guilin in the 1960s, before the River Li became saturated with cruise ships. Rafts strung together from bamboo glided silently over the waters that mirrored the surrounding mountains.

The shallow river winds its way between peaks that are startling in shape and whose names conjure up characters from Chinese mythology, such as the woman-like figure at the "Yearning-for-Husband's-Return" Rock. The landscape changes at every turn: sometimes a waterfall, sometimes a small hamlet nestling in one of the "phoenix tail" bamboo groves so typical of the region. My small boat drifts along at water level and, in the dappled light that changes with the landscape, I am filled with a sense of peace, a source of inspiration. When I arrive at Yangshuo—a small town on the banks of the river after the sugar-loaf mountains—my head is swirling with images and my sketchbook full of ideas. The streets are virtually traffic-free, with only the odd crop-laden tractor passing every now and then. Rice paddies fan out at the foot of each peak, covering every available plot of arable space. This rich, well-irrigated earth yields three harvests a year. Bare-footed peasants drive buffalo, furrowing the flooded fields.

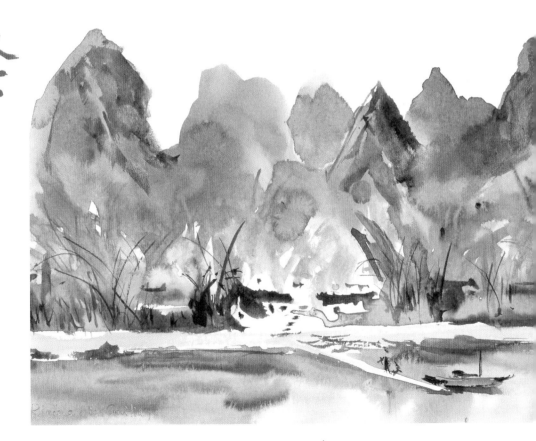

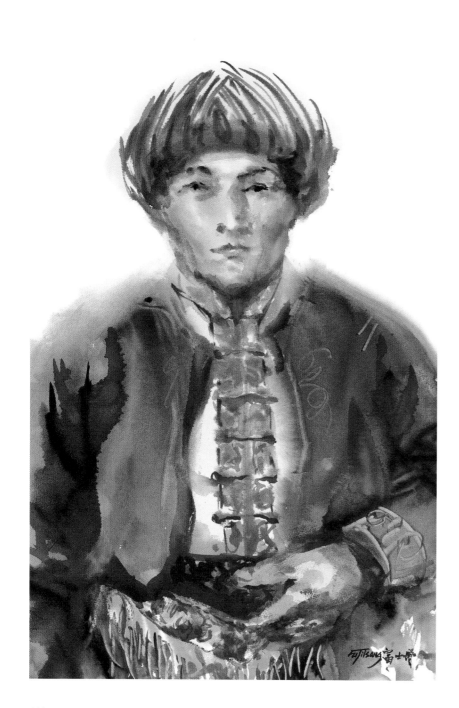

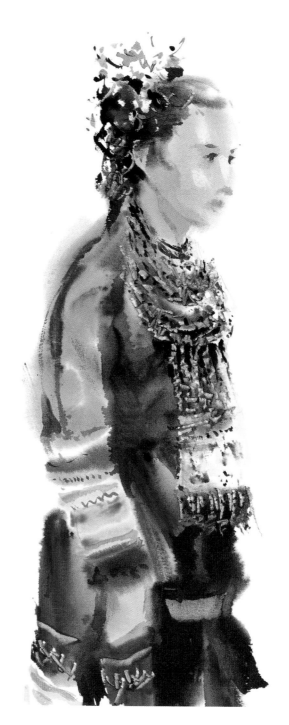

CHINA
Land of sixty ethnic minorities

MIAO COUPLE IN FESTIVE DRESS (FACING PAGE)

OLD NAXI WOMAN (RIGHT)

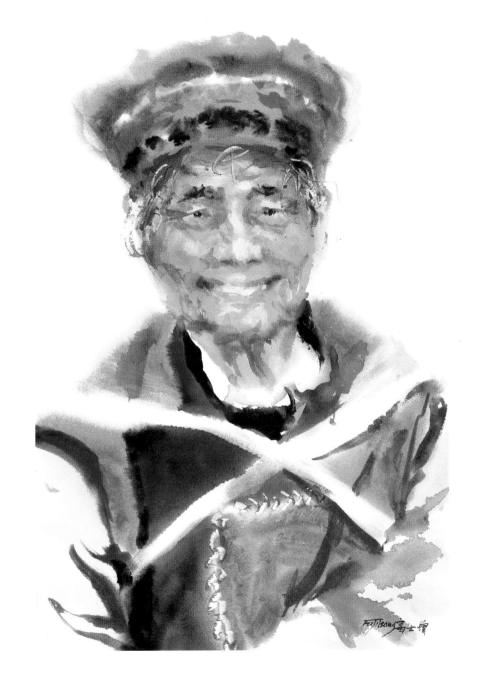

Far from being a homogenous land, China is home to a large number of minorities. The birthplace of Chinese civilization is situated on the high plateau of the Yellow River in the region of Xian and Luoyang. When Emperor Qin Shi Huang first unified the empire to form the Middle Kingdom, Mongols and Tibetans already figured among the Chinese population. During the Qing dynasty under Manchu rule (1644–1911), the country stretched from Siberia to the north as far as Asia Minor and Tibet to the west. Chinese influence extended to Indochina to the south and Korea to the east. The Han account for around 93 percent of the population. The remainder is made up of fifty-five ethnic minorities. The Zhuang inhabit Guangxi province, which is known for Guilin. Along with the Yao, Miao, Dong and Jing, they comprise 75 percent of the population of this region.

Certain minorities have left a more specific mark on the history of China.

The Mongols, whose Yuan Empire (1277–1368) stretched from Vietnam to Hungary, conquered China and Russia with Genghis Khan.

The Manchus, nomads from the north of China and central and eastern Siberia, invaded China in 1644 and founded the Qing dynasty. Unlike the Mongols, they were to embrace Chinese culture completely, improve the mandarinate system and take the Hans into their service. Several Manchu emperors were discerning men of letters and famous calligraphers, as well as being fearsome warriors.

My great-grandfather on my father's side was a Manchu Mandarin. Although I count myself to be a fully-fledged Chinese, I regret being unable to understand the Manchu language and the complex characters of its writing system.

Like the Mongols, the Tibetans were Manchu allies during the conquest of China. The Qing emperors appointed Tibetan Buddhism as Court religion and the Lamas enjoyed a privileged status. To the north of Beijing, one of them even built a small Potala after the palace/monastery of the Dalai Lama in Lhasa. He presented this architectural gem to his mother for her sixtieth birthday. The Lama Temple, with

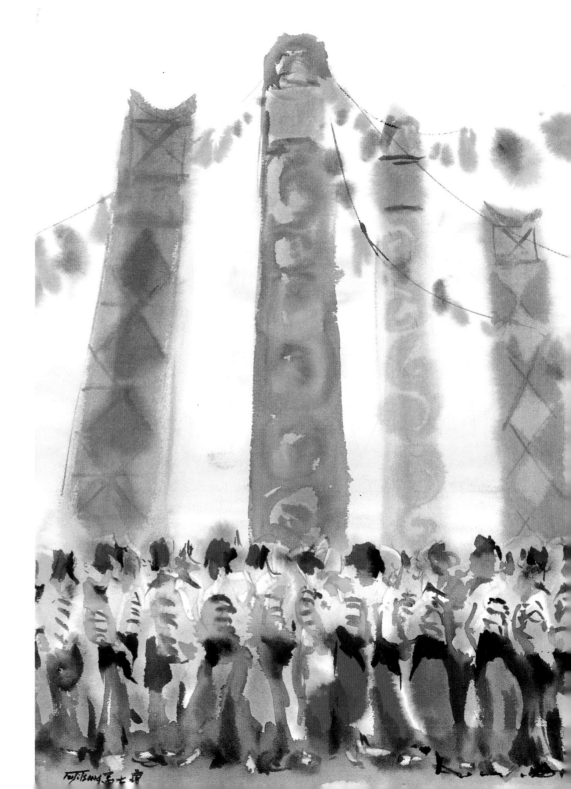

its lavish decorations, stands in the center of Beijing. Generation after generation of Panchen Lamas, the second most important dignitary in Tibetan Buddhism, have resided there.

There are just under three hundred thousand Naxis, descendants of Tibetan nomads, living in the provinces of Yunnan and Sichuan. Like many other minorities of these regions, they have preserved a matriarchal tradition. In Naxi society, men have been able to give free rein to their creativity in the fields of calligraphy, music and painting, for which they are highly reputed.

Naxi calligraphy, a writing system using pictograms that goes back over a thousand years, is both original and picturesque. It is somewhat reminiscent of Egyptian hieroglyphs. Naxi music stands as a valuable living testimony to the rhythms of ancient China, whereas Chinese music *per se* has evolved through contact with other cultures. In Lijiang, I went to a concert given by Xuan Ke, a learned Naxi of Tibetan origin. It was a delight for me to listen to his commentary full of wit and humor.

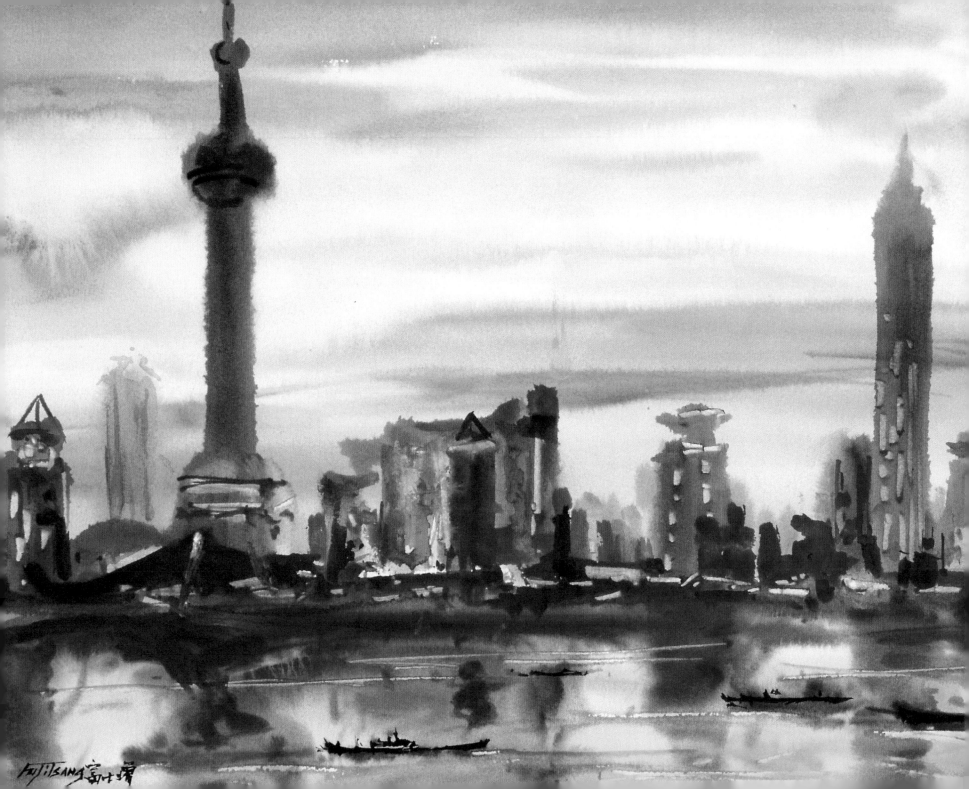

SHANGHAI
A true megalopolis

PUDONG AND THE HUANGPU RIVER (FACING PAGE)

SHANGHAI AT NIGHT AGAINST BUND BACKDROP (RIGHT)

Located at the mouth of the Yangzi River, Shanghai is a place of superlatives. With over thirteen million inhabitants, it is the largest city in China and probably in the whole of Asia. The world's biggest building site, a countless number of residential buildings and offices spring up like young bamboo shoots in the Pudong district. Young Shanghailanders all want to be the "most fashionable" and the "hippest" in the country. The port and stock market set their sights on outshining Hong Kong. Yet, just a hundred years ago, Shanghai was a mere market town. The implantation of Western concessions has enabled the city to evolve rapidly, becoming the country's business center. Even today, granite buildings with their austere façades bear witness to this bygone age. Yet they pale into insignificance beside the skyscrapers—all glass and steel, and each one higher than the next—when seen from the other bank of the Huangpu. Six- or seven-tiered expressways traverse the city, intersecting in a flurry of entrance and exit ramps and spiral junctions. Our poor driver, a native of Suzhou, spent a good hour trying to negotiate this jungle of overpasses. Finally, at twilight, we were driving along slowly

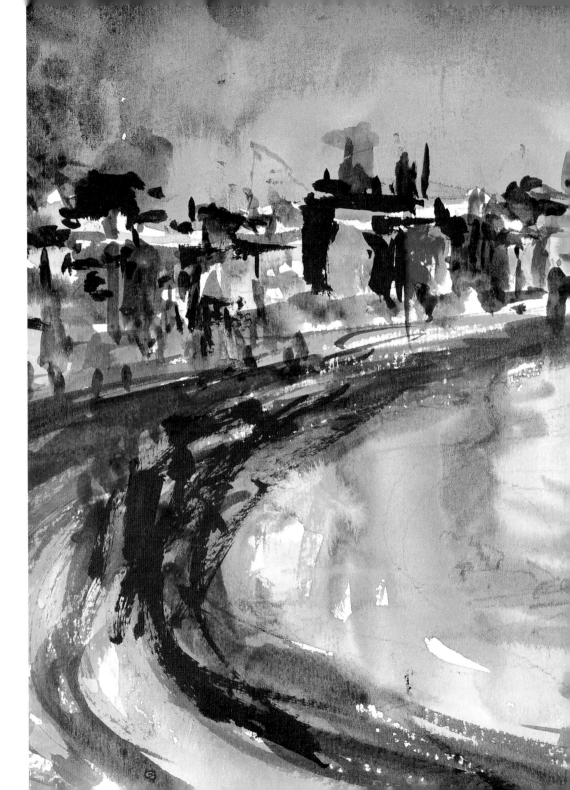

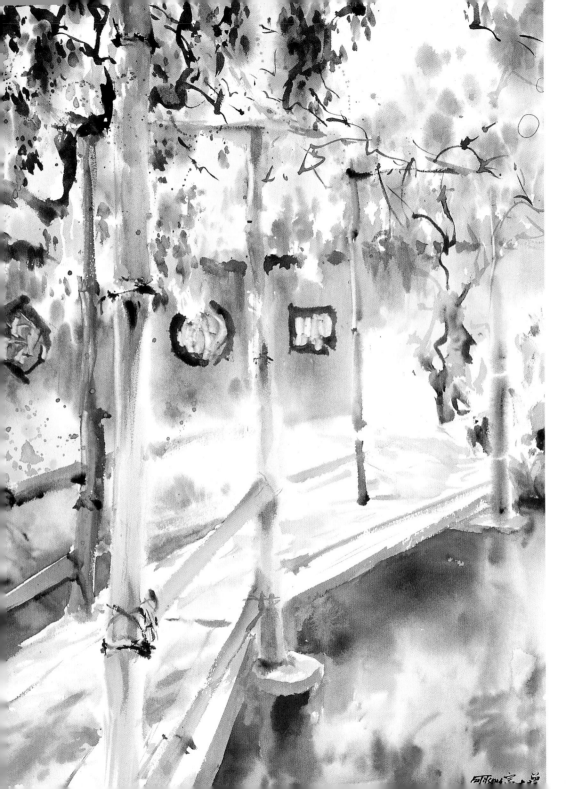

SMALL BRIDGE AND BAMBOO PERGOLA (LEFT)
Bamboo is omnipresent in Chinese culture.
The literati were particularly fond of this symbol
of the upright nature of human behavior.
Bamboo poles are used in construction,
for scaffolding—even in skyscrapers.
Its shoots, especially when fresh, are delicious fried.

FORMER FRENCH CONCESSION IN SHANGHAI (FACING PAGE)

when we miraculously came across a police box on a windswept road. It was almost surreal to see a policeman in such a place! We could not have been the only ones to lose our bearings on these isolated roads perched so high up.

The two-storied buildings lining many *linong*s—narrow backstreets in the city center—have been razed to the ground and replaced with soulless high-rise blocks. Fortunately, one typical quarter has been carefully preserved and restored: the old town surrounding the Temple of the Town Gods. Traditional two- or three-storied buildings adorned with streamers and multicolored flags draw crowds towards reputed restaurants and shops, sometimes a hundred years old.

Another site of interest is the Yu Yuan Garden (Yu the Mandarin's Garden) encircled by a wall surmounted with gray tiles that is a daring representation of a dragon with a long, supple body. Perched on a rocky hillock, a small pavilion provides well-read Mandarins with the isolation conducive to creation and meditation. Reflected in a pool of sinuous shape can be seen a wall with a round opening in imitation of the full moon, or a vermilion pavilion that stands in cheerful contrast to the surrounding vegetation. I almost

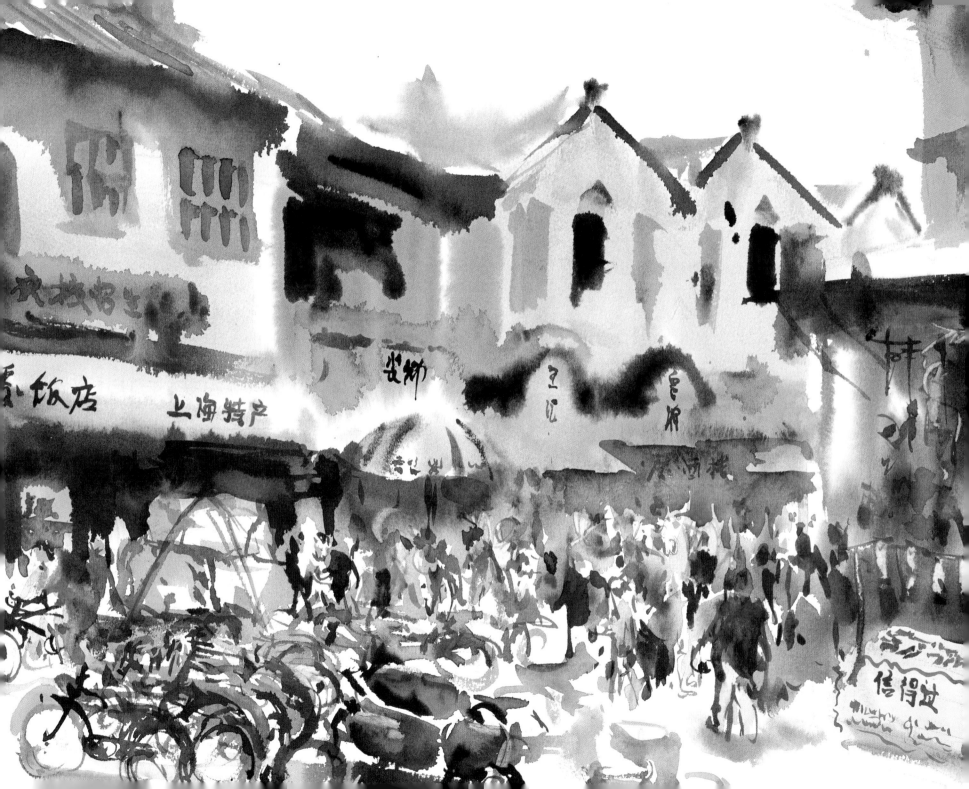

forget that we are in the city center and am only brought back to reality by the jostling of the crowds.

This megalopolis seems to make up for its lack of past by the creation of large cultural centers and sports complexes. The wonderful Shanghai Opera House was designed and built by French architect Charpentier. The Shanghai Museum houses one of the most important collections of bronzes and paintings in China. Inspired by the practices of Western museums, the different sections are clearly laid out and the objects skillfully displayed to advantage and judiciously labeled. We marvel to see these treasures that seem to take on new life in order to recount the ten thousand-year history of Chinese civilization. Outside, on the esplanade, modern buildings of all styles stretch for as far as the eye can see. Is this a foretaste of the China of tomorrow laden with promises? Let us hope that the country will become liberated without disowning its roots, that it will become modernized without forgetting its past, that it will evolve without destroying its environment and that it will open up to the world by offering visitors its prized possession—its age-old culture.

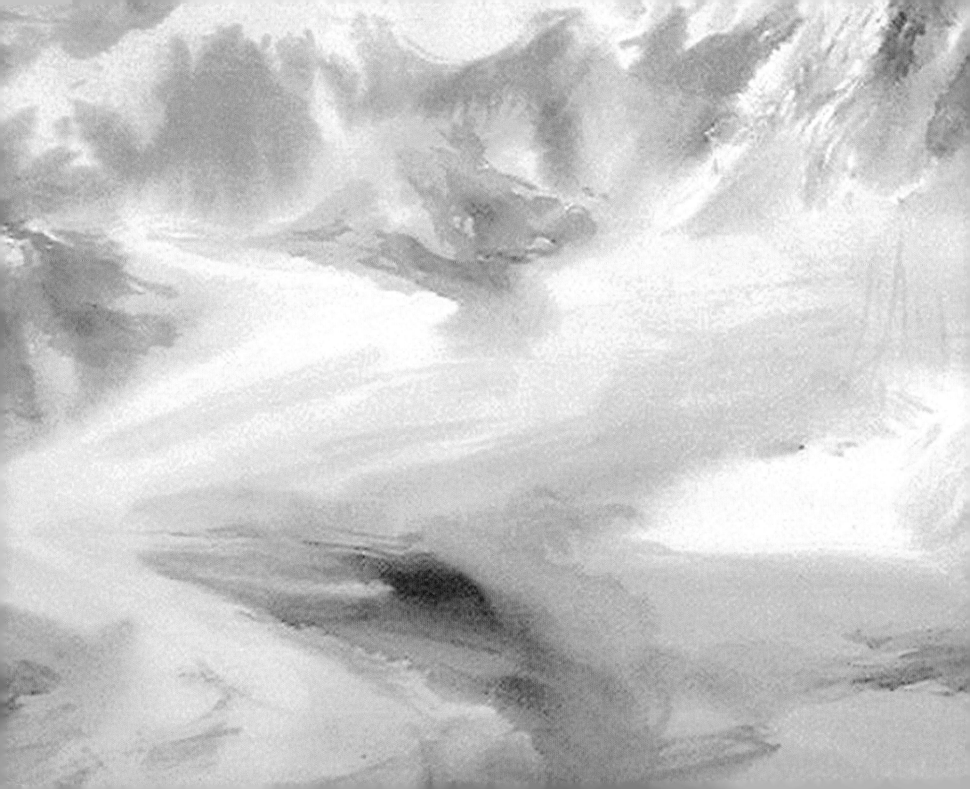

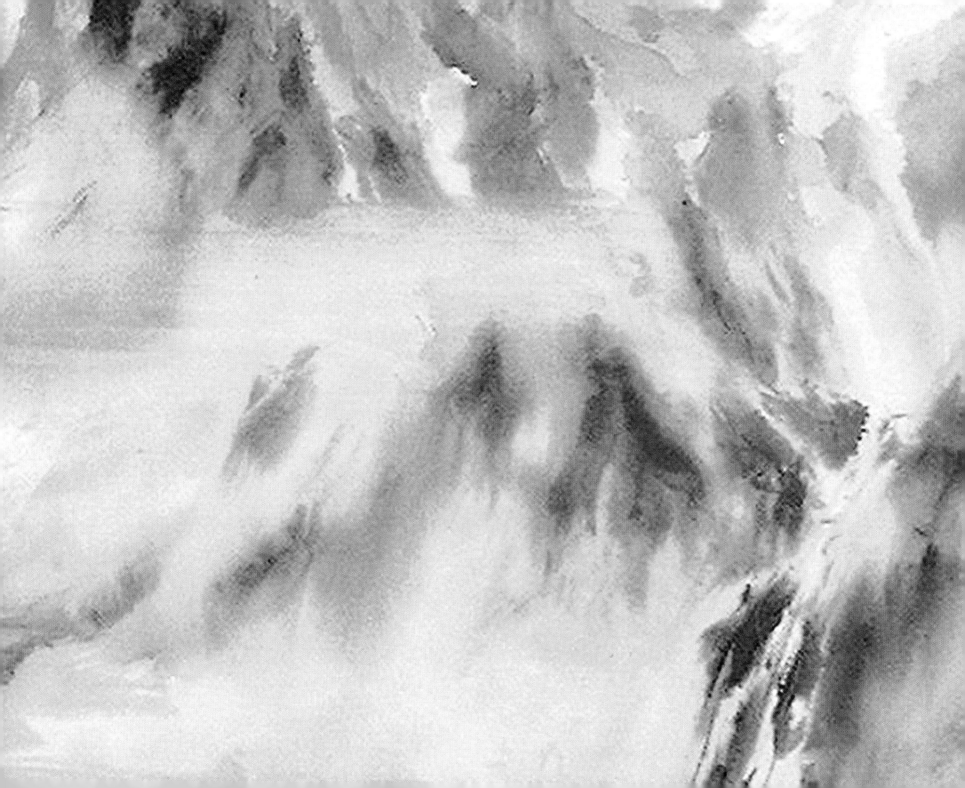

All my love to my parents
and my wife, who have always
supported me in my artistic research.

My affection to Cuc Hoa Tran
whose calligraphy is used in this book.

My heartfelt gratitude to Claudine
and Roger Tran, Maryse Karcenty,
Michèle Fallara, Jacques and Claude Raunet,
Jocelyne Trémollières, and many
other friends for their warm
and patient assistance.

FU JI TSANG